MONSTER FACTORY

DRAW CUTE AND COOL CARTOON MONSTERS

MONSTER FACTORY

DRAW CUTE AND COOL CARTOON MONSTERS

ERNIE HARKER

WITH SCOTT JARRARD AND KEN CHANDLER

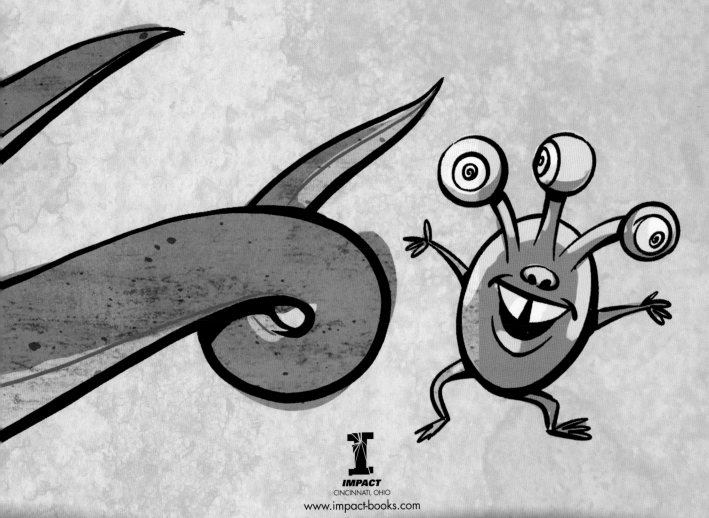

IMPACT
CINCINNATI, OHIO
www.impact-books.com

CONTENTS

WHAT YOU NEED

You don't have to have fancy supplies to draw monsters. Here's what you need to get started:

- Paper
- Pencils
- Erasers
- Pens
- Crayons, markers, colored pencils or paint for coloring

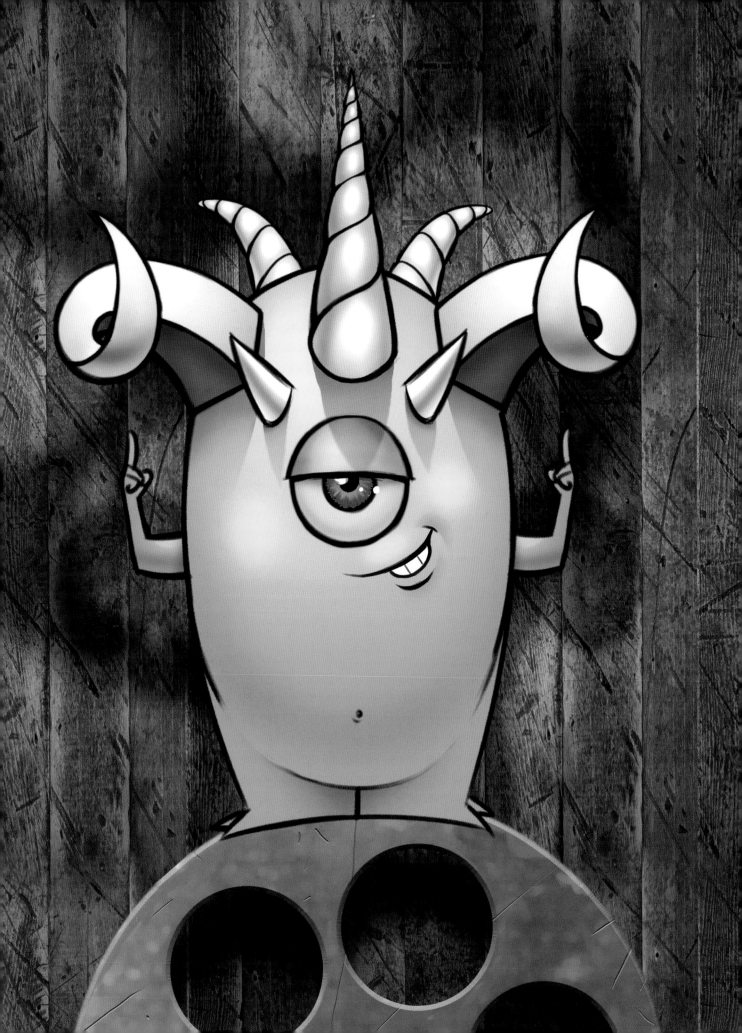

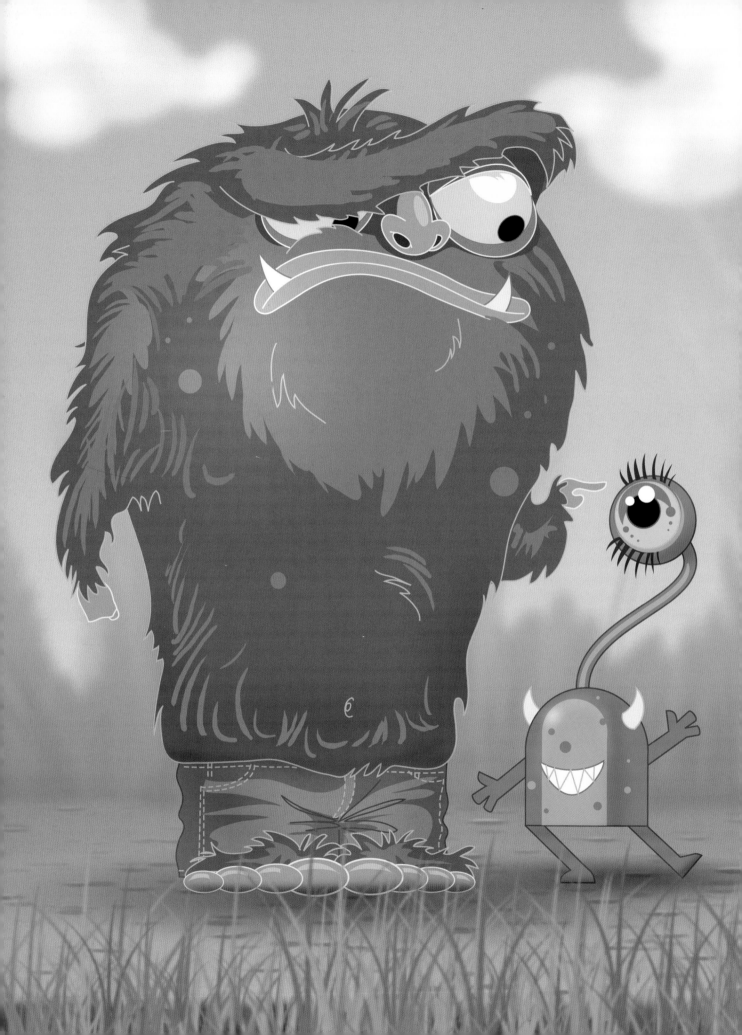

INTRODUCTION

As humans, we notice each other's differences and can spot the tiniest abnormalities. I've been drawing people and studying anatomy professionally for over twenty years, and I still sometimes draw one eye slightly lower than the other or a hand that looks a little wrong. Sometimes I lose confidence in my drawing ability when my friends notice something "not quite right" in my drawings of people. But monsters are inherently quirky, weird, twisted and disproportionate. No one will say, "Those eyes are too close together" or "Those hands are too small." Monsters live in our imaginations, and whatever we can dream up we can draw.

I'm lucky to be friends with some amazing professional artists who constantly inspire me. I've invited two of them to contribute to this book so you can be inspired too. Ken Chandler, Scott Jarrard and I will each explain the techniques and processes we use to develop our characters so you can see the similarities and differences of our approaches.

Monsters can be terrifying, the stuff of nightmares! But I think there's plenty of scary things in the world already, so I've decided to draw monsters that would be so adorable, you'd want to keep them as pets. As you draw these adorable monsters, relax, don't worry about being perfect, and enjoy the process that makes being creative so much fun!

SETUP AND MATERIALS

High-Tech Materials

I sketch and paint using Corel Painter and Adobe Photoshop® on a Macintosh computer and a Cintiq drawing tablet. While this setup does not improve my drawing skills, it allows me to quickly fix mistakes and explore variations in my drawings. Even though I work on a computer, I still carry a sketchbook.

Basic Materials

When I'm drawing with pencil and paper I use lots of sharp Prismacolor pencils in Black and Non-Photo Blue. I use a white high-polymer eraser, a rubber kneaded eraser, and marker paper or animation paper. These papers are slightly transparent, which makes it easy to see drawings behind it. I can tear out my drawing and slide it under the next page to explore different eyes, mouths or other body parts. When I find something I like, I bring my main drawing back to the top and sketch over the feature that I really liked.

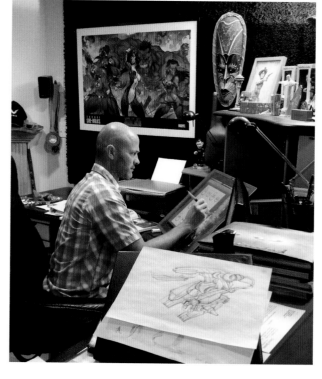

My Preferred Setup

The perfect setup for me is to block out a couple hours or more in my basement studio (usually late at night when the kids are in bed), pour an ice-cold soft drink, turn on my favorite music, switch on my drawing light and start sketching. I'll often get so caught up in what I'm doing that I forget to go to bed until way after midnight.

My Materials

Pencils, erasers and paper are all you need to get started drawing monsters.

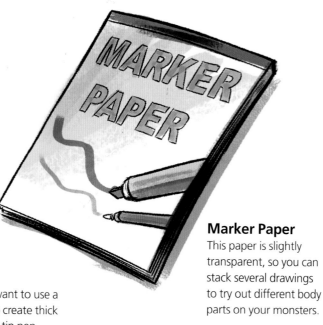

Pens

If you ink your monsters, you may want to use a soft brush tip that makes it easier to create thick and thin lines, or you can use a fine-tip pen.

Marker Paper

This paper is slightly transparent, so you can stack several drawings to try out different body parts on your monsters.

THE DRAWING PROCESS

When I watch some of my artist friends work, it looks really easy. It appears that they never make a mistake, but that's not really true. They just have a tried-and-true process that makes their drawing appear effortless. Here is my basic drawing process. Give it a try, and soon you'll be drawing monsters easily, too!

 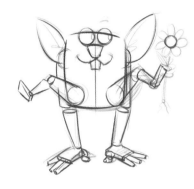 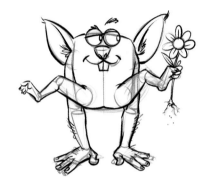

1 Start Loose and Light
Start drawing loose and light with a pencil or a light colored pencil. Block in the major shapes and proportions. Sometimes it looks like a scribble.

2 Draw Contour Lines
Draw contour lines on the basic shapes to help visualize the surface of the form.

3 Add Details
When you feel good about the overall shape and proportions, start to tighten up the drawing, erasing guidelines and overlapping lines. Add details by pressing harder or by using a darker pencil. Scott loves to ink his drawings, so if you like his inked look, trace over your drawings with a fine-point black felt-tip pen or flexible brush marker.

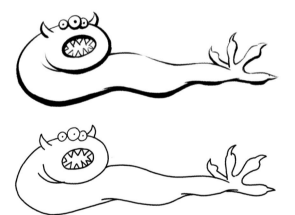

Wait! A Word About Line Weight

Line weight helps bring your characters to life by suggesting 3-D volume. Use a thick, dark line when the line is holding weight (like the underside of the belly) or when the surface is bending or bunching. Use thinner, lighter lines to suggest a light source or surface tension.

Think of a line as a thin rubber pipe. When it's relaxed, the bottom of the pipe will have a shadow, but there isn't any surface tension. When it's bent, the outer curve will experience a lot of surface tension spreading the line thin while the surface of the inner curves will bunch together making the line thicker and heavier.

Without variations in line weight, your drawings will look flat and lifeless.

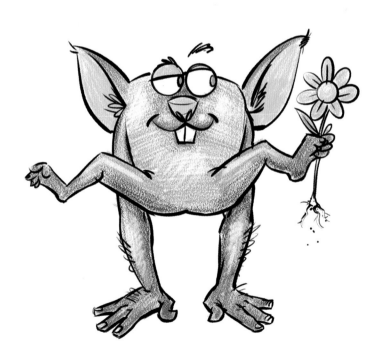

4 Add Color
I usually color my drawings in Photoshop, and sometimes I use Painter. You can use markers, colored pencils, crayons or anything you like.

MONSTER INSPIRATION

Monsters are a distortion of reality, drawn from our imagination and inspired by the world around us. To invent fun monsters, first study and draw from the real world, then let your imagination run wild.

Characters come to life when they have a story, so I encourage you to invent the story of how your monster digs, jumps, eats, hunts and so on. These details will inspire you to add the features that help make your monster believable. If your monster jumps, give it big strong legs like a frog, grasshopper or kangaroo. If it lives underground, give your monster claws that help it dig, similar to a hedgehog's or gopher's.

Check out these little monsters and notice the similarities to their real world counterpart.

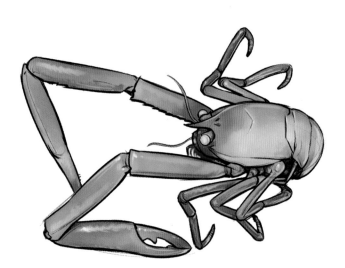

Squat Lobster

Lobsterbot

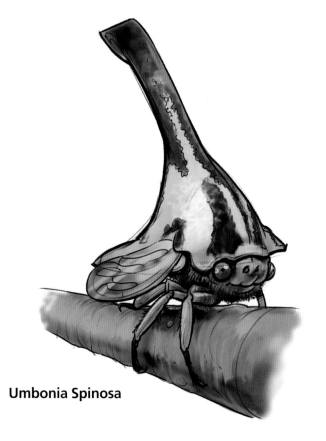

Umbonia Spinosa

Umbonia Troll

Dumbo Octopus

Dumbopus

Sea Pig

Pigworm

Isopod

Isobot

1 BUCKET OF PARTS

This chapter will focus on the parts and pieces that make up a monster: eyes, mouths, noses, horns, body shapes, arms, legs and claws. We'll build a bucket of monster parts that you can pull from to create your own crazy monsters. Be sure to draw each example more than once. As you draw these features you will add them to the library in your brain. Once they're in your brain, you can check them out as often as you like!

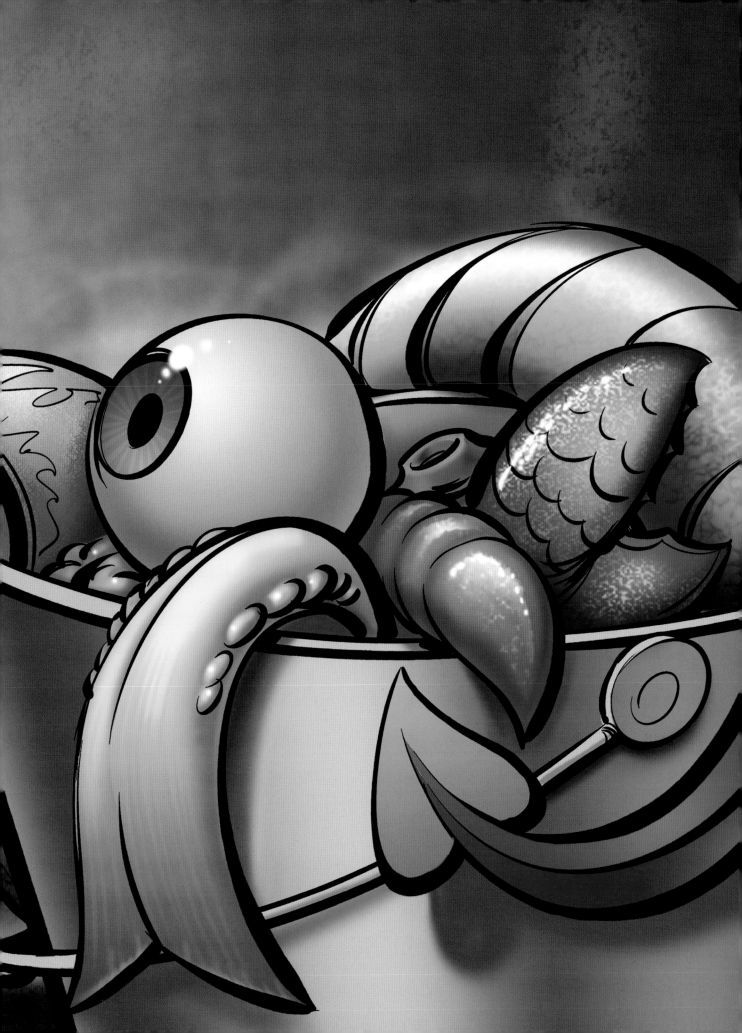

EYE ANATOMY AND EXPRESSIONS

Eyes are the window to the soul and can tell you more about the attitude and personality of your monster than almost anything else. If your monster is friendly, sad, angry, surprised or confused, the eyes will show it. Below is the basic anatomy of the eye and a variety of monster expressions, shown both in a straight-forward view (the round faces) and a three-quarter view (the jelly-bean-shaped faces).

Eye Anatomy Lesson
The eye is basically a wet glassy ball. It is partially covered with an upper and lower eyelid. The eye has an iris (colored part) and a pupil (the black center). The iris is actually a muscle that automatically expands and contracts to allow more or less light into your eye. Because the eye is wet, you will usually see a highlight.

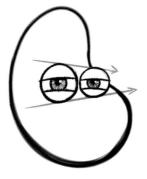

Normal Expression
Irises of relaxed monsters rest on the bottom eyelid. The upper eyelid drops down into the colored iris or sits just above the pupil. An emotionally stable monster's eyes will be nearly the same shape and size.

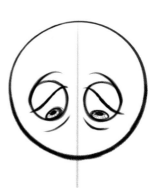
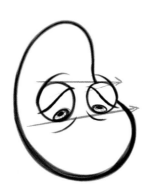

Sad or Relieved Expression
Sad or relieved eyes have large irises and upper eyelids that sag low into the eyeball. For a sad monster, add a small mouth that is turned down on the edges. For a relieved monster, add a smiling mouth.

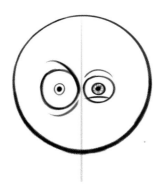

Crazy Expression

A confused or crazy monster who is not quite sure what he's thinking or feeling has eyes of different shapes and sizes.

Surprised Expression

Surprise or frighten a monster, and its pupils dilate (get really small), and its eyelids stretch away from its eyeball.

Cute Expression

Cute monster eyes have big irises, big pupils and two or three highlights of various sizes.

Evil Expression

The eyelids of evil monsters partially cover the eyeball and angle upward on the outsides.

EYE LIBRARY

After you draw all the eyes in this chapter try inventing your own. Go crazy! Mwaahhahhaahaaaa!

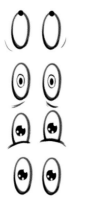

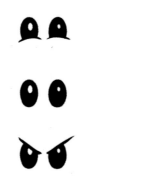

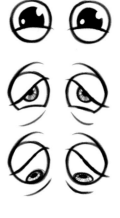

Frightened or Surprised Eyes
Tall oval eyes make your monster look frightened or surprised, especially when drawn with small irises and pupils.

Beady Eyes
Beady eyes are drawn without the eyeball or eyelids. They are simple to draw and can be used to make your monster appear cute or creepy, depending on how large you draw them and where you position them on the monster's face. I like to leave a highlight to give them a wet look.

Symmetrical Eyes
Here are a few more examples of symmetrical eyes. Not all symmetrical eyes make your monster look normal.

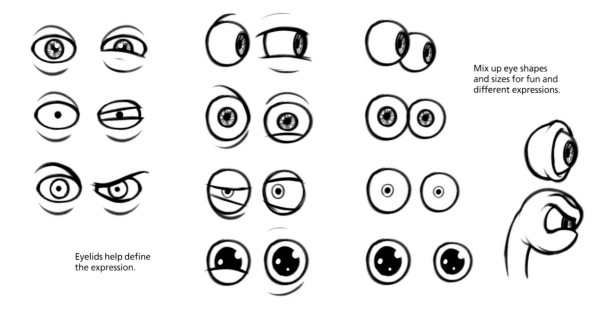

Mix up eye shapes and sizes for fun and different expressions.

Eyelids help define the expression.

Asymmetrical Eyes
Here are a few more examples of sets of eyes that are different shapes and sizes. Draw eyes like this to make your monster appear confused or crazy.

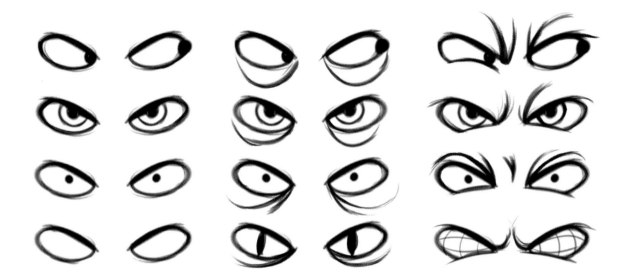

Evil Eyes

Learn how to change your monster's expression with these evil-looking eyes. Draw bags under the eyes with curves that begin at the inside corners to make your monster look old. Make your monster angrier by drawing furrowed eyebrows that curve slightly over the eyes in arches that end in the inside corners of the eyes.

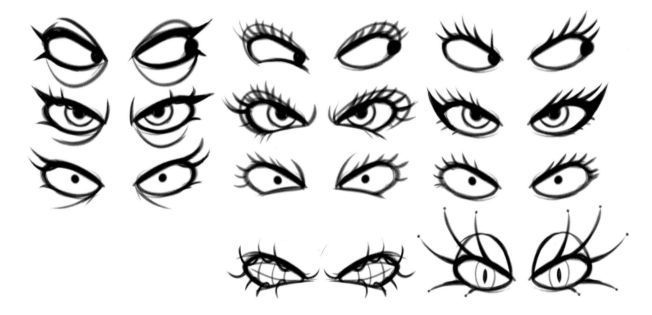

Evil Eyelashes

Turn your monster into a girl—add eyelashes. Eyelashes are always drawn from the eyelid and can be long or short, thick or thin. Practice drawing different types of eyelashes inspired by these evil-looking eyes.

MOUTHS

Monster mouths are stretchy openings in faces that hide teeth. Adding teeth, lips or tongues can give your monster character and help you show whether it's scary, friendly or goofy.

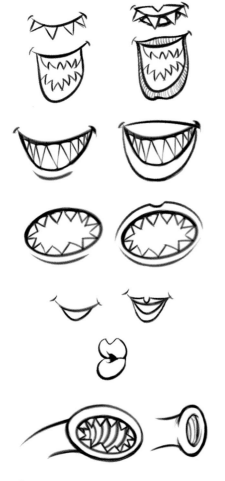

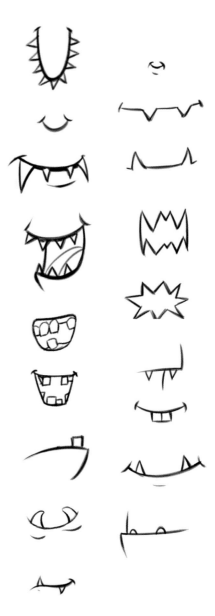

Tongues

Tongues are really fun to draw and make excellent additions to monster mouths.

Lips

Some monsters have lips and some don't. Here are some examples of the same mouths with and without lips so you can see the difference. I've also included two weird suction hose-type mouths because they look like they have lips too.

Teeth

Skinny pointed teeth look evil. If you draw teeth that are flat or rounded, your monster will look safer and less intelligent than monsters with pointed teeth. You can even incorporate teeth into the shape of the mouth. No teeth or straight teeth look friendly.

NOSES AND SNOUTS

Do monsters smell? They'll need a nose or snout to give them a sense of smell whether they smell bad or not. Some have nostrils and some don't. Draw these noses and snouts to add them to your creative mind's bucket of parts.

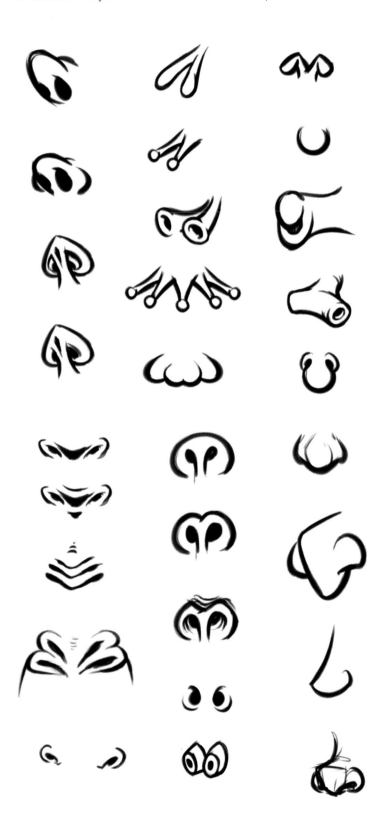

Monster Nose Options
Noses in the animal kingdom usually have two nostrils. But your monster could have only one, more than two, or even little antenna sensors or feelers. Maybe your monster doesn't even need a nose at all and it smells using its tongue like a snake!

HORNS AND TAILS

Sometimes your monster needs to accessorize. Horns and tails are both great ways to give your monster a unique look.

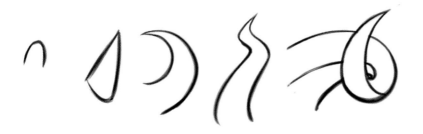

Horn Shapes
Horns are basically cones of different shapes and sizes. They can grow straight or they can twist and turn.

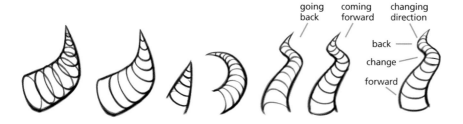

Striped Horns
You can draw stripes on your monster's horns for a wild and zany look! Stripes are just single lines drawn around the surface of the horn. They look like ovals when drawn all the way around. Lightly draw ovals inside the horn shape. Erase half of each oval and darken the rest. The curve of the oval can make the horn look like it is angling toward you or away from you.

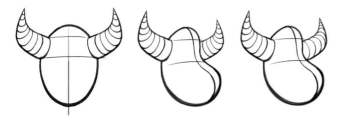

Horn Symmetry
Horns are usually symmetrical. When drawn facing the viewer, the horns should be mirror images of each other. Note how the stripes make the horns appear to be coming forward toward you (left figure). The example in the center is drawn incorrectly because its left horn (on the far side of its head) appears to be growing straight out of the front of the face rather than the opposite side of the head. The figure on the right is drawn correctly. Notice how the stripes on both horns are drawn curving the same way. This makes the horns appear symmetrical.

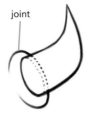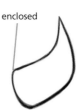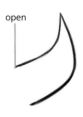

Ways to Connect Horns
Here are three ways a horn can connect to the monster. You can use a simple method of enclosing the horn (middle) or leaving it open (right), or you can draw a joint where tissue is built up at the base of the horn (left). After drawing the horn, lightly sketch an oval that is slightly larger than the bottom of the horn at its base. Next, erase a small portion on the side closest to you.

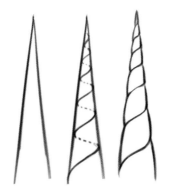

Straight Unicorn Horns

Try drawing spiraled unicorn horns. Lightly sketch a long, tall cone. Then lightly draw a wavy line where the curves touch each side of the cone. Imagine that you are drawing a single line on the surface of the cone spiraling around the cone from the bottom to the top. Notice how the curves get closer together as they near the top. Erase every other line. (The erased lines look like dashed lines in my drawing.) Next, darken the remaining lines and add a little bend to the line connecting each segment.

Curved Spiral Horns

Use the same method for curved horns. Imagine drawing a single line on the surface of the horn spiraling from the bottom to the top. The spiraling line should flow smoothly without suddenly changing direction.

Antlers

Try giving your monster crazy shaped antlers like those of a deer or a moose. Even in the real world, antlers can be any shape or size.

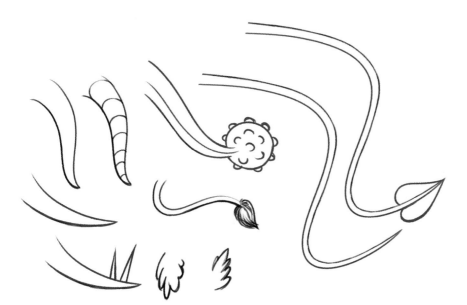

Tails

Pin the tail on your monster!
Tails are generally long, tapered and curvy. Start by drawing a gently curved line. Then begin at the end and draw another line that follows the same curve but gets wider as it goes up. Depending on how your monster uses its tail, you can add something at the end such as a club, a tuft of fur, spikes or a spade. You can even make it look zany by adding stripes, using the same method used to add stripes to horns. Remember to make the line for the underside of the tail thick and dark to show weight and shadow.

LEGS, ARMS AND CLAWS

Your monster has to get around, so let's draw some arms and legs to get your monster on the move. Follow these easy step-by-step instructions. Use these basic foot and leg drawing principles to create your own variations of limbs for monsters of your own invention.

Three Toes

1 Draw an L
Draw a leaning backwards L-shape.

2 Add a Second L
Add a second, more open backwards L that touches the end of the first L and tapers a little at the top.

3 Draw an M
Draw a rounded m-shape beginning in the angle of the L. The left part is much narrower than the right.

4 Draw a V
Draw a V-shape from the middle of the m to the end of the m.

5 Add a Triangle
Add a triangle with a short, flat bottom halfway up the inside of the leg.

6 Clean Up
Erase the overlapped lines, and you've got a three-toed leg.

Draw More Feet and Tentacles!
Get free bonus demos on pig feet, two-toed feet, sneakers, bunny feet and tentacles at impact-books.com/monster-factory.

Chicken Feet

1 Draw Lines and a Smile
Draw two vertical lines that are slightly wider at the bottom. Add a "smile" near the bottom of the lines.

2 Add Two Curves
Add two curves from the edge of the smile.

3 Draw a Second Smile
Draw another "smile" with two shorter curves that touch at the ends.

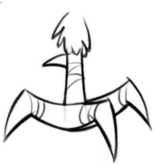

4 Draw a Curved V
Draw a curved V-shape to one side where the inside of the V is shorter than the outside.

5 Add Wrinkles and a Talon
Add C-shaped wrinkles, a V-shaped talon and some feathers at the top.

Turtle Leg

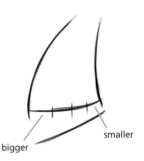

1 Draw Curved and Diagonal Lines
Draw two curved lines that get close together at the top. Connect them with a flat bottom. Lightly draw another diagonal line that drops down to the left.

2 Add Three Short Lines
Lightly draw three short lines that are spaced wider on the left and smaller on the right.

bigger

smaller

3 Add Curved U-Shapes
Add curved U-shapes to each of the short lines from Step 2. The bottom of each U touches the diagonal line below.

4 Mark the Knee
Add an oval to mark the knee. The top and the bottom of the oval are darker than the sides.

5 Add Wrinkles
Add wrinkles to the knee and erase the bottom diagonal guide.

23

Spider Legs

1 **Draw a Curve and V-Shape**
Draw a curve for the underside of the spider and a wide V-shape that drops down from the belly then up and away.

2 **Finish the Leg Line**
Add the rest of the leg with two more lines.

3 **Thicken the Leg**
Beginning at the toe, draw a darker line that gets wider at the first joint and narrow at the next joint.

4 **Finish Thickening the Leg**
Make the leg a little wider to the next joint and then taper back to the body.

5 **Add the Joints**
Add some lines for the joints.

Pinchers

1 **Draw Two Circles**
Draw a big circle with a dot in the middle and a smaller circle that slightly overlaps the edge.

2 **Draw a Third Circle**
Draw another circle between the original circles. It is darker at the bottom and disappears at the top.

3 **Add a Curved V-Shape**
Draw a curved V-shape with the point at the lower part of the middle circle. The legs of the V are to the outside edge of the large circle.

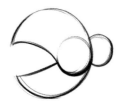

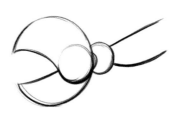

4 **Clean Up the Lines**
Darken the outside edges. Erase the dot and the line between the V-shape.

5 **Add the Arm**
Draw an arm connected to the smaller circle. It is flatter on the top and curved underneath.

Claws

1 **Draw an Oval With Lines**
Lightly sketch a tilted oval with two diagonal lines that get wider at the top.

2 **Draw an M-Shape**
Draw a pointy M-shape on the opposite side from the arm lines.

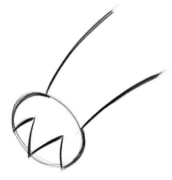

3 **Darken the Lines**
Darken the outside lines.

Hands

1 **Draw an Oval and Rectangle**
Lightly draw an oval and a diagonal rectangle that is rounded at the bottom. This will be the palm.

2 **Add a Thumb Oval**
Draw a smaller oval near the top that's slightly tilted to the right. (The middle line is just a guide to show that it's tilted.) This will be the thumb.

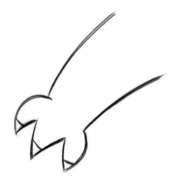

4 **Clean Up and Add Claws**
Erase the inside lines and add some claws.

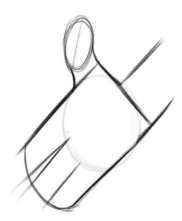

3 **Add the Wrist and Fingers**
Add a wrist at the top and connect the thumb to the palm. Add fingers between the oval of the palm and the rounded end of the rectangle.

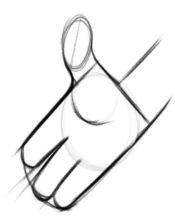

4 **Finish the Fingers and Thumb**
Round the ends of the fingers, and add a curve for the thumb on the palm.

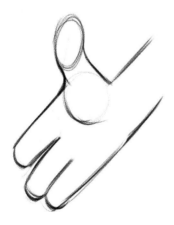

5 **Clean Up**
Erase the lines you don't need.

SHAPES AND SIZES

Everybody has a body—even monsters! The examples on this page demonstrate how much character comes from the body shape and its parts.

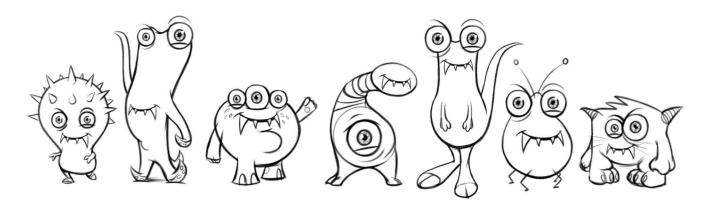

Same Features, Different Body Shapes

Here I've drawn seven different body shapes but used the same basic eye shapes and mouth on each monster. (I'll bet you didn't realize that until I told you.) Isn't it amazing that the different body shapes and the position of the features create such different monster types?

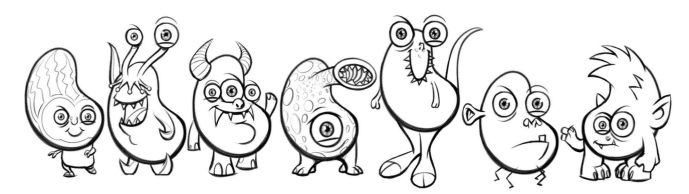

Same Body Shape, Different Features

Here I've used the same simple kidney bean shape for the body and basically the same eye shape, but the mouths and noses are all different. Even these monsters look completely unique.

Share Your Monsters!

Share your monster drawings and find additional demos, tutorials and contests on the *Monster Factory* Facebook page: facebook.com/MonsterFactoryBook.

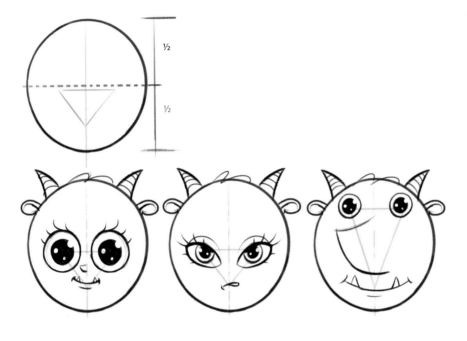

The "Cute" Triangle

If you want your monsters to be cute, use the "cute" triangle as a guide. Lightly draw a small triangle that points down just below the center half of the head. Draw large eyes in the top corners of the triangle and a tiny mouth at the bottom. Add a tiny bump of a nose or none at all and you've got an adorable little monster that you'll want to cuddle.

Notice how the image on the far right doesn't follow this formula. His eyes are small, spread apart and near the top of his head. He has a huge nose and a broad mouth. Definitely *not* adorable!

Shape Possibilities

Monsters come in every shape imaginable. I randomly drew these six shapes to demonstrate that you can make a monster from any shape. In the next chapter you'll learn to draw monsters from some of these same random shapes.

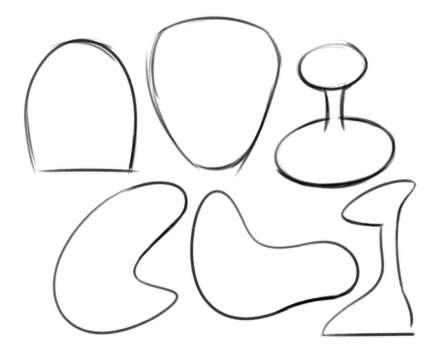

2 MONSTER ASSEMBLIES

Now that you've learned to draw a variety of monster eyes, noses, mouths, arms, legs, horns, tails and more, it's time to put them together. Some combinations will look really cool and some won't. Like all true geniuses, you'll learn by trial and error. In this chapter you'll be like a mad scientist, making five new monsters from your bucket of parts. Put on your lab coat and let's get started!

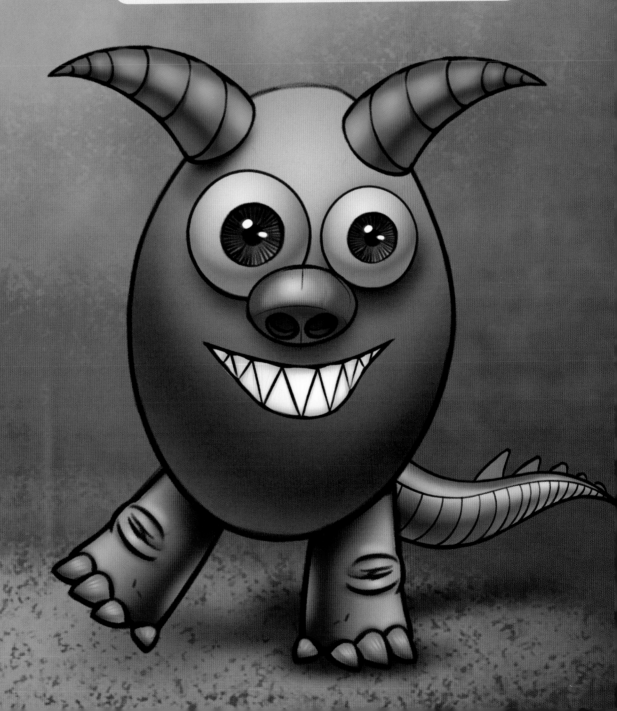

Jeremy

This is Jeremy, a monster who began life as a jelly bean.

1 **Draw a Jelly Bean**
Draw a jelly bean shape. It doesn't have to be perfect.

2 **Make Face Guidelines**
Very lightly, draw a curved X as a guideline for the horizontal and vertical center of the face.

3 **Draw the Eyes**
Draw two eyes with the bottoms on the horizontal guideline. The eye farthest away should be slightly smaller in perspective.

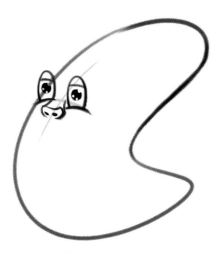

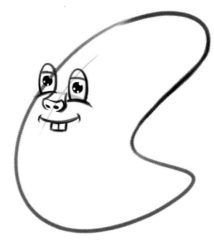

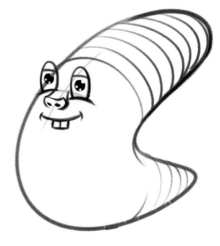

4 **Add a Nose**
Draw a nose between the eyes.

5 **Draw the Mouth**
Then draw a mouth with two teeth sticking out beneath the nose.

6 **Add Stripes**
Form stripes with curved lines for visual interest.

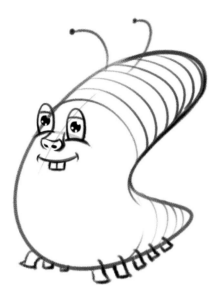

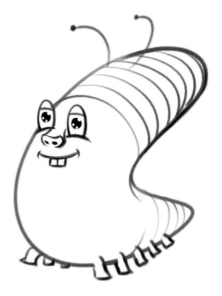

7 Draw Legs and Antennae
Add some simple square legs and C-shaped antennae.

8 Erase Extra Lines
Erase the lines behind the legs and the X guideline behind the face.

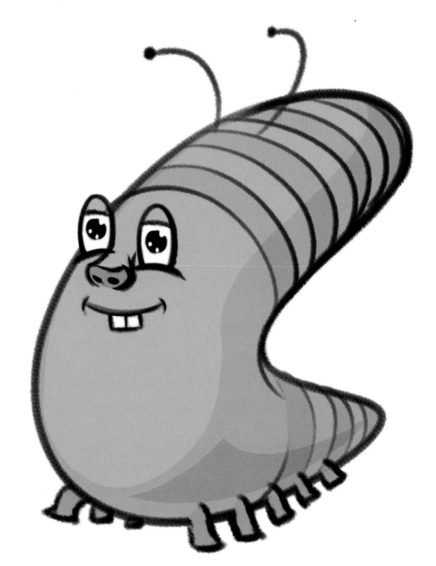

9 Add Color
Color your monster however you wish. I made mine lavender and purple. You can be assured that for someone who began life as a jelly bean he's as sweet as he looks.

Buddy

Buddy has a tombstone-shaped body, and it looks like he's looking forward to the circus coming to town.

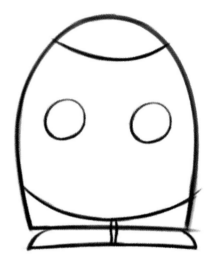

1 Draw the Body and Add Curves for the Clothes
Begin by drawing a bulging tombstone shape. Add a curve to the top for his hat and a curve at the bottom for the top of his pants.

2 Start the Eyes and Feet
Add two circles for eyes in the middle of the tombstone and a horizontal line below for the bottom of his feet.

3 Form the Heels and Toes
Draw two short vertical lines for his heels and chart curved lines for his toes.

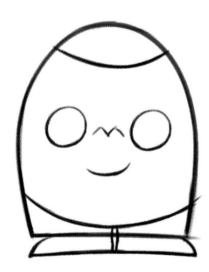

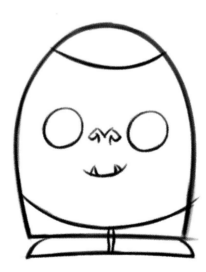

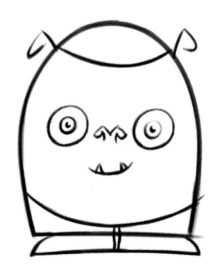

4 Draw the Nose and Mouth
Draw a flat M-shape between the eyes for the top of his nose and a smiling mouth below it.

5 Finish the Nose and Add Teeth
Add two little teeth and the bottom of his nose.

6 Start the Ears and Finish the Eyes
Draw the beginning of two ears where his hat meets his head and add the irises and pupils to his eyes.

 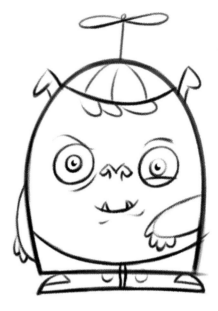

7 Add Hair and Arms
Sketch three tufts of hair at the bottom of the hat and add two arms.

8 Finish the Ears and Add More Features
Finish his ears and add his eyelids, fingers and chin.

9 Finish the Hat and Shoes
Add the details of the hat and shoes and it's ready to color.

10 Add Color
Color your monster however you wish. Buddy looks so cute in his propeller hat that I'd hate to disappoint him. Try drawing some circus monsters to entertain him!

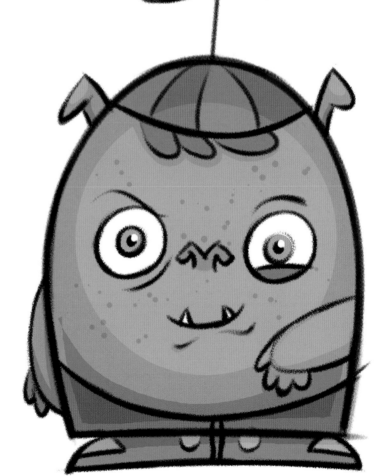

Stephanie

Stephanie needs someone to hug and can't wait to wrap her tentacles around you!

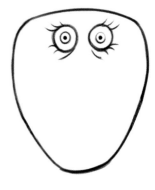

1 Draw the Body Shape
Begin by drawing an egg shape that's a little flat on the top. Remember, it doesn't have to look perfect to look good.

2 Start the Eyes
Add two circles for eyes near the top of the egg.

3 Add Eye Details
Add the center of the eyes, lashes and some little bags under the eyes.

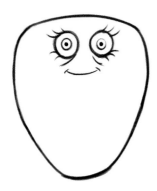

4 Draw the Mouth
Stephanie is happy, so draw her a smile.

5 Start the Tentacles
Draw some loopy curvy lines from the top of her head and from each side. These are going to be tentacles.

6 Finish the Tentacles
Establish the thickness of each tentacle by drawing another line that follows the same curve but gets narrower as it reaches the end. It's OK to draw through the other lines. This helps you keep a good-looking curve. You can erase lines later.

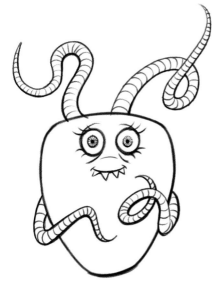

7 **Add Teeth and Finish the Eyes**
Add short jagged teeth, upper eyelids and irises.

8 **Add Shading and Erase Extra Lines**
Add some shading between the teeth and erase the lines where the tentacles overlap her sides and themselves.

9 **Stripe the Tentacles**
Add striped bands to her tentacles using the same steps as outlined in the Horns and Tails section.

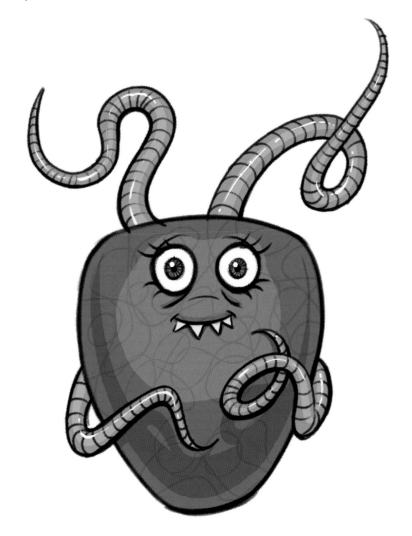

10 **Add Color**
Use any materials you like to color your monster. How can you resist giving a hug to someone who can really wrap her arms around you?

Barbara

Barbara looks like a board game piece that has turned into a spider. Kinda creepy but with kissable lips.

1 Draw the Body and Head
Draw a large oval for a body and a small oval above it for a head. Draw a neck with two short vertical lines that pinch slightly in the middle.

2 Draw the Eye and Mouth Shapes
Lightly draw two large eyes in the top oval. Then draw a small oval just left of center in the bottom oval for the mouth.

3 Add the Top Eyelids and Lips
Add dark arcs diagonally through the eyes for the eyelids, and add the shapes of the lips in the oval for the mouth.

4 Develop the Eyelids, Lips and Belly
Draw the bottom eyelids, the center of the lips shaped like a V lying down and an ellipse paralleling the bottom of the body for a belly line.

5 Add Facial Feature Details
Draw the pupils, and darken the lashes and the lip shape (especially the bottom). Then add details to the upper and lower eyelids following the curve of the eyeball.

6 Draw Antennae, Legs and Tail
Add antennae to the head and eight little legs from the belly line. Draw a curvy tail.

7 Draw the Tail Details
Add a spade and a line through the center of the tail and you're ready to color!

8 Add Color
Use your favorite supplies to color your monster. Barbara gives a new meaning to pretty ... ugly.

Jason

This little monster looks mean enough to slug. Get it? Slug! Ha ha.

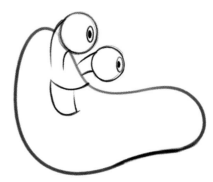

1 Start the Body, Eyes and Mouth

Lightly sketch a fat boomerang shape for a body. Remember to make the line at the bottom of the body thicker and darker than the line at the top.

Draw a curve for a mouth that touches the bend in the boomerang-shaped body and two circles for eyes.

2 Finish the Eye and Mouth Shapes

Add the stems for the eyes and the lower lip.

3 Draw Irises and Pupils

Draw small vertical irises and pupils centered near the right side of the eyeballs. Erase the body line behind the left eyeball.

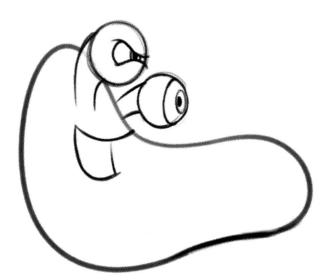

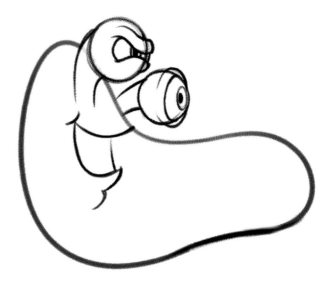

4 Add Eyelids

Draw a pinched shape on the left eyeball and a larger oval on the right eyeball for eyelids. Erase the iris and pupil outside the pinched shape.

5 Develop the Eyelids

Make thick eyelids by drawing a curve that parallels the top of the pinch for the left eye and a larger ellipse that doesn't quite connect on the left side for the eyeball on the right.

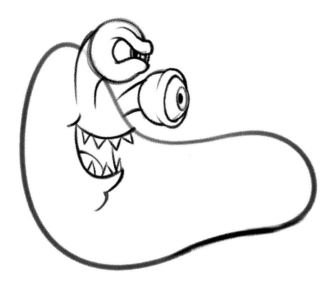 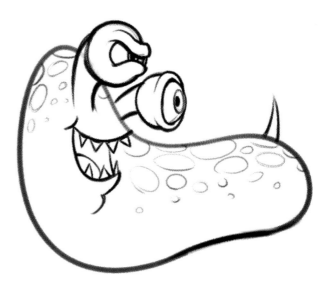

6 **Erase Extra Lines and Draw the Teeth, Tongue and Chin**
Erase the eyeball lines behind the eyelids and add triangle teeth, a tongue and a chin.

7 **Add Spots and a Tail**
Lightly add spots and a thorn-shaped tail.

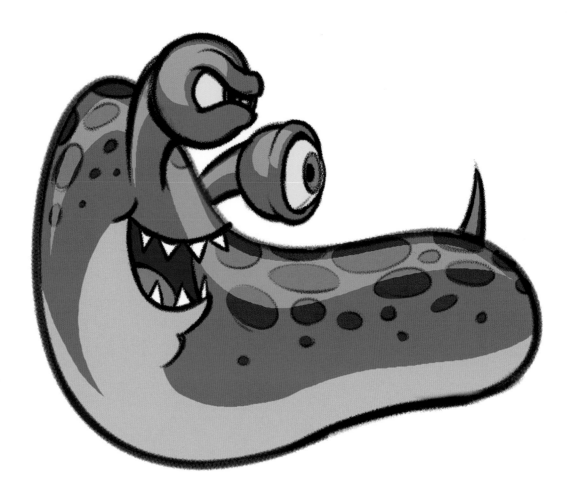

8 **Add Color**
Color your monster with your favorite materials. Don't you think this mean little monster deserves a slug?

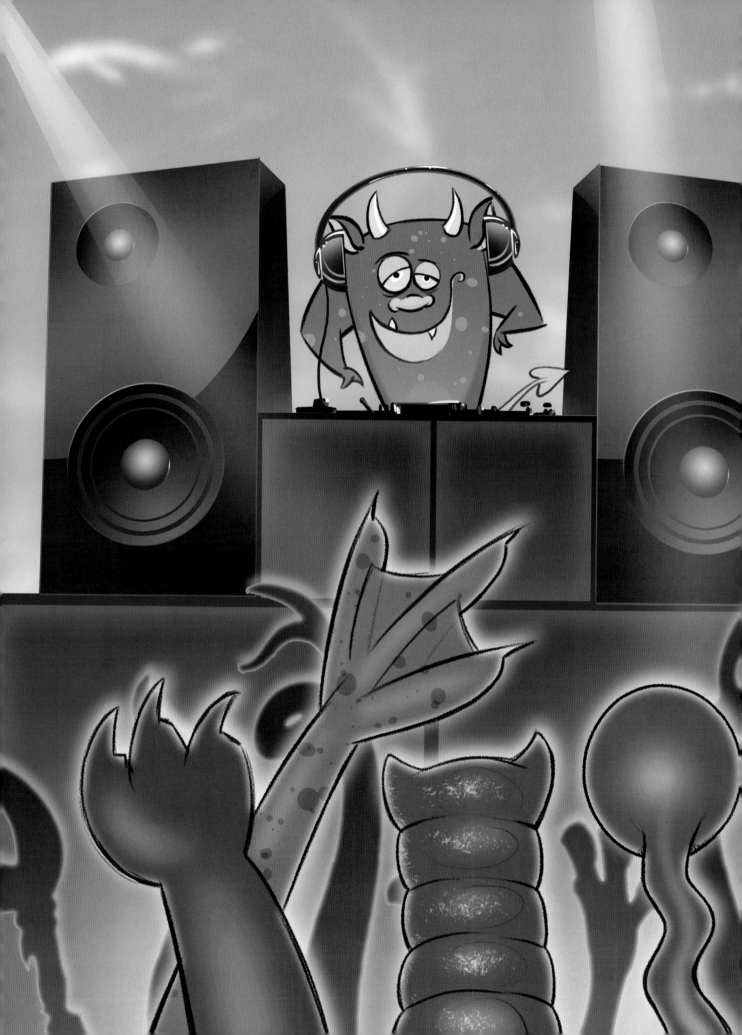

3 FREESTYLE MONSTERS

We've learned a lot of monstrous character drawing skills! Now it's time to lay down some monsters freestyle. These monsters are inspired by our imaginations with no rules and no limits.

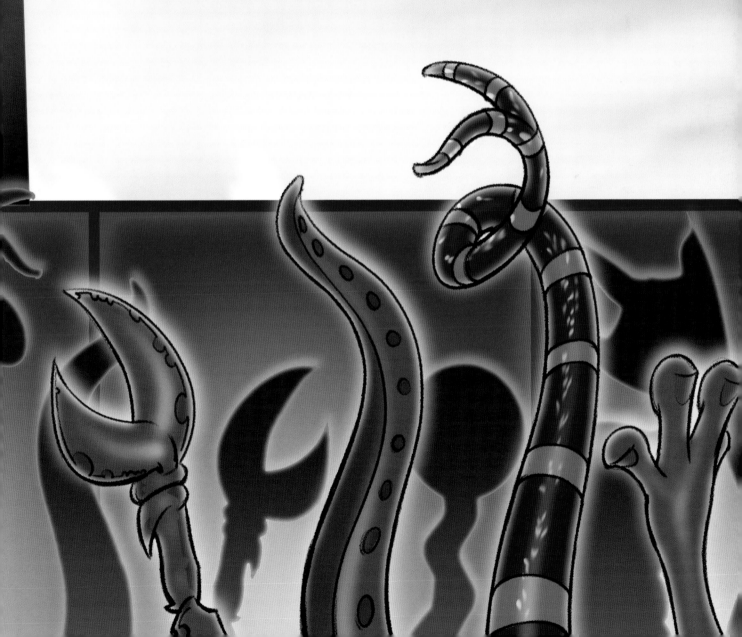

Squats

Squats has never had a balloon before, and he's afraid it might blow away.

1 Draw the Body, Eyes and Mouth
Draw a fat, wide upside-down U-shape with two feet for the monster's body. Then draw an upside-down smile inside the body.

2 Add Arms and a Third Leg
Draw three circles above the body for eyes. Add fat stumpy arms and a third leg off-centered between the other two legs.

3 Connect the Eyes and Add Teeth
Connect the eyes to the head and draw in some square-ish teeth.

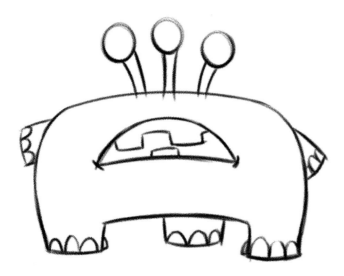

4 Add Toenails and Fingernails
Draw toenails and fingernails with U-shaped arcs at the end of each arm and leg.

5 Develop the Eyes and Teeth
Draw in the pupils and curved lines separating the teeth from the gums.

6 Draw Hair and Wrinkles
Add curly hair on top, wrinkles to the knees and ridges to the nails.

7 Add a Balloon
Draw an oval for a balloon and draw a string in the hand on the left.

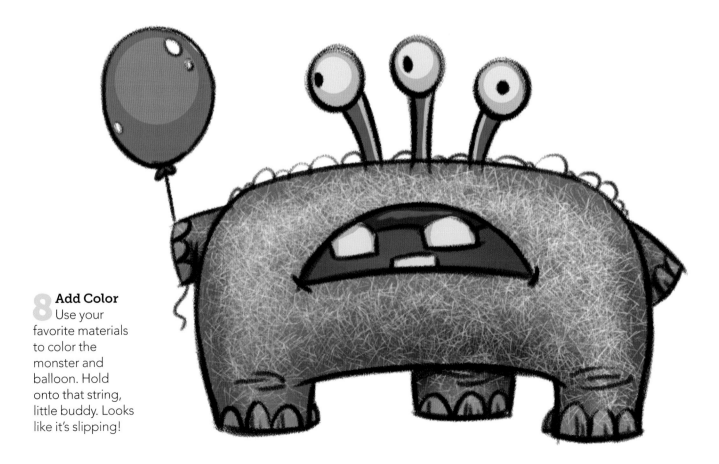

8 Add Color
Use your favorite materials to color the monster and balloon. Hold onto that string, little buddy. Looks like it's slipping!

Monolizard

He's a happy, fat lizard monster with an eye on a good time.

1 Draw the Body and Mouth
Lightly draw an upside-down egg shape that's leaning to the right.
Draw a smile shape just left of center that slightly overlaps the outside edge of the egg.

2 Develop the Face and Chin
Draw a dark line from the front of the smile to the bottom of the egg for a chin. Next, draw the face beginning near the front of the mouth. The line should be flat, then bumps out of the egg shape on top, then meets the egg shape at the back of the head.

3 Clean Up and Add the Eye
Erase the lightly drawn lines. Draw a large oval above the smile and close to the left side of the face for an eye. Draw a curved eyelid that dips down on the right, then draw a pupil and iris.

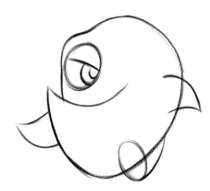

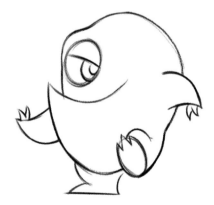

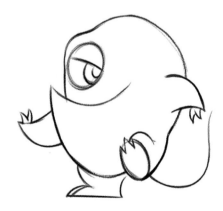

4 Add Arms and a Leg
Add fin-shaped arms, an oval for a foot and a curve from the heel to the body for a leg.

5 Clean Up and Add Claws, Feet and Toes
Erase the overlapped lines and add two claws at the end of each fin and three-pointed toes in the raised foot. Draw a short horizontal line for the bottom of the foot. Then, draw a pinched V-shape for the foot and a curved line for the heel.

6 Add a Toe and Start the Tail
Add a toe on the standing foot and a curvy line for the center of a tail.

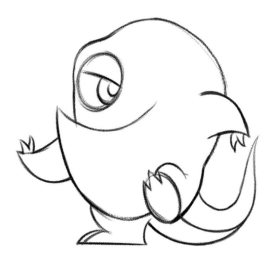

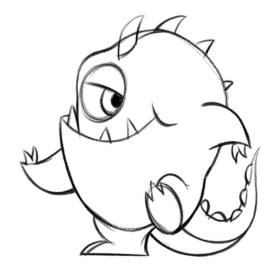

7 Develop the Tail Shape
Draw the curves of the top side and underside of the tail.

8 Add Teeth and Spines
Add triangle-shaped teeth, triangle-shaped spines on his head and bumpy spines on his tail.

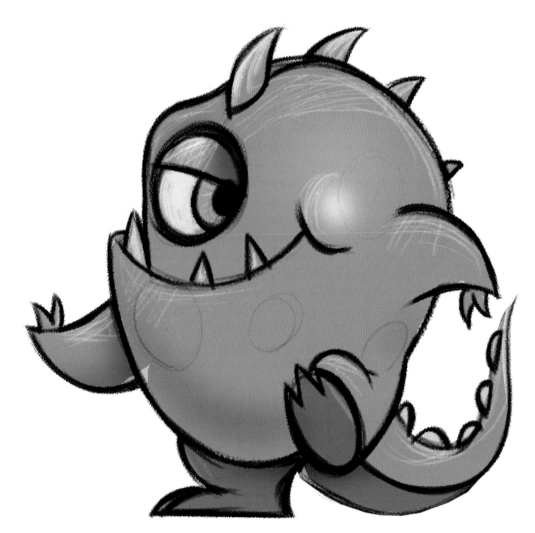

9 Add Color
Darken the underside lines on the belly, arms and eyes, then erase the body line in the top horn before coloring. He's got tiny little arms. I wonder how he washes his horns?

Peanut

Yo! You down with the hip-hop Peanut slug?

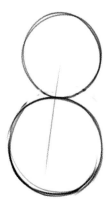

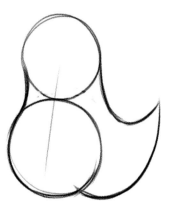

1 Start the Body Shapes
Lightly draw two circles. The circle on the top should be leaning a little to the right.

2 Finish the Body
Connect the two circles with a dark curve on the left and a "phat" tail shape to the right.

3 Develop Shapes for the Tail, Eye, Mouth and Feet
Take a chunk out of the bottom of the tail shape and erase the outside edge of the chunk. Erase the body circles. Draw a small circle for an eye where the two circles touched. Draw an oval for a mouth and two circles for feet. Draw the tops of the foot circles very lightly.

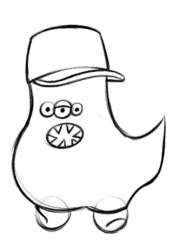

4 Add Two More Eyes
Add two smaller circles for eyes, one on each side of the middle eye.

5 Start the Hat and Toes
Add a curve in the top of the head for a hat. Draw an S-curve for the foot on the left and a small curve for a toe on the right foot.

6 Develop the Eyes, Teeth and Hat
Draw pupils on the eyes, an upper eyelid on the center eye, triangular teeth and a bill at the bottom of the hat. Square off the top of the hat.

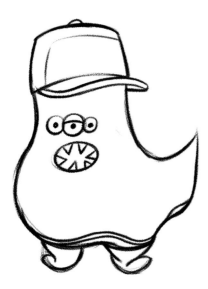

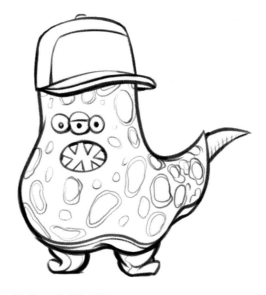

7 **Finish the Hat, Tummy and Feet**
Lightly draw the face of the hat and add curvy parallel lines at the bottom for his tummy. Finish his feet.

8 **Add a Tail and Skin Texture**
Draw a thorn-shaped tail and lightly sketch some wavy circles on his skin.

9 **Add Color**
Color your monster however you like. This rapper is ready to lay down some tracks … snail tracks!

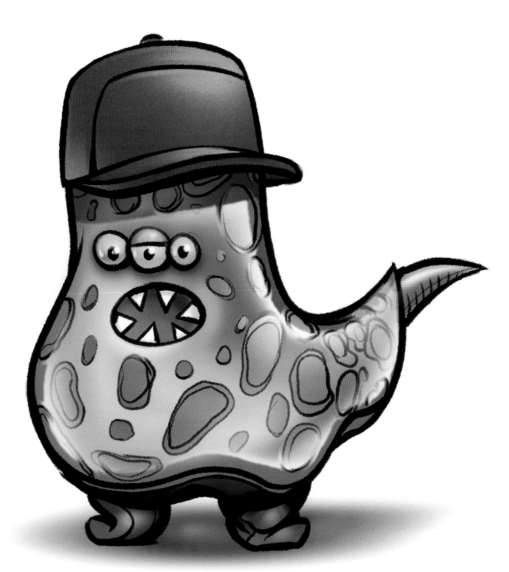

Ray

Ray has a stingray-shaped head. That's why we call him Ray. Can you help him get ready for school?

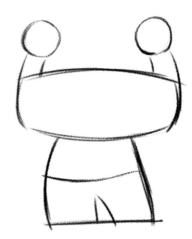

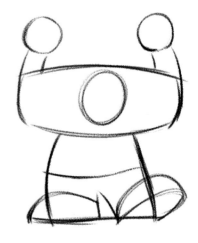

1 Draw the Head, Body and Eyes
Draw a flat wide rectangle with bulging sides for a head sitting on a bulging square body with a flat bottom. Divide the bottom square in half with a wavy horizontal line. Draw two circles above the head for eyes.

2 Attach the Eyes and Divide the Legs
Connect the eyes to the head with short antennae that line up on the outside of the head. Draw an upside-down V-shape at the bottom to separate his legs.

3 Start the Snout and Feet
Lightly draw an oval in the middle of the head and two round feet with flat bottoms, one raised.

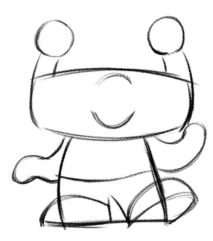

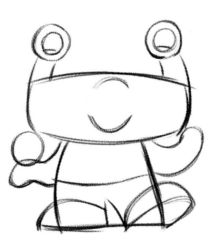

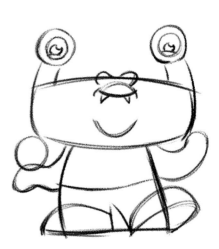

4 Develop the Snout and Arms
Erase the sides of the face oval and draw curvy arms that begin where the head meets the body.

5 Develop the Eyes and Start the Apple
Draw circles for eyes with arcs for lower eyelids and a circle for an apple above the arm on the left.

6 Add Pupils, Mouth, Teeth and Nose
Draw pupils with highlights, a smile with two teeth and two bumps for a nose.

7 **Draw the Clothing**
Draw in the details of a shirt collar, sleeves, buttons and a pocket.

8 **Add Textures and Details**
Darken the lines and add the wrinkle and texture details. Erase the unnecessary lines.

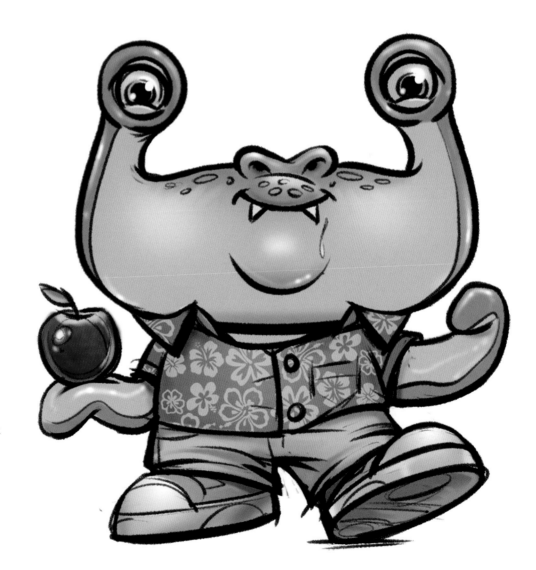

9 **Add Color**
Add any colors you like to finish your monster. All dressed up and holding an apple, Ray makes school look cool.

Disco Devil

This little devil wants to dance the night away, so let's boogie.

1 Start the Body, Arm and Leg Shapes

For the body, draw a medium-sized arc that's slightly tilted down on the left and curved lines from each end that get closer at the bottom.

For the arms, draw the outside edges of the arms from the top two corners. Draw the legs as continuations from the sides.

2 Complete the Arm and Leg Shapes

For the legs, draw an upside-down U-shape leaning to the right. Finish sketching the arms, making them thick at the shoulders and thin at the wrists.

3 Add Fingers and Toes

Draw two toes on the bottom of each leg and two fingers on each wrist.

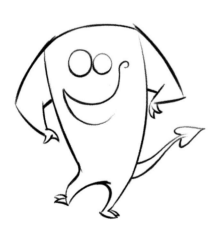

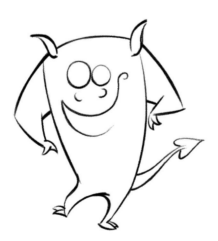

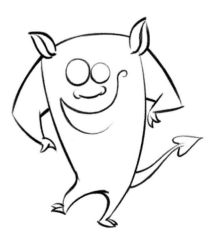

4 Add Eyes, Smile and a Tail

Draw two circles for eyes, one slightly larger than the other. Then draw a crazy curvy smile.

Add a tapered tail that ends in a heart-shaped spade.

5 Add a Nose and Ears

Draw two C-curves beneath the eyes for the sides of the nose and a tear-shaped ear on each shoulder.

6 Finish the Ears and Nose

Finish the ears and draw a smile-shaped curve at the bottom of the nose.

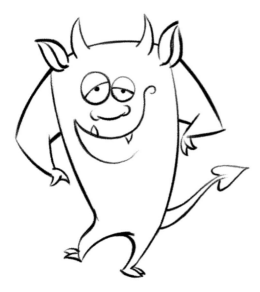

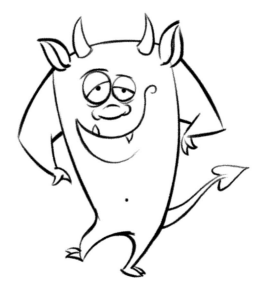

7 **Add Eye Details and Teeth**
Add eyelids, pupils and two teeth.

8 **Add a Belly Button and Face Details**
Add a belly button, a curve for the top of the nose and curves above and below the eyes to make him look tired.

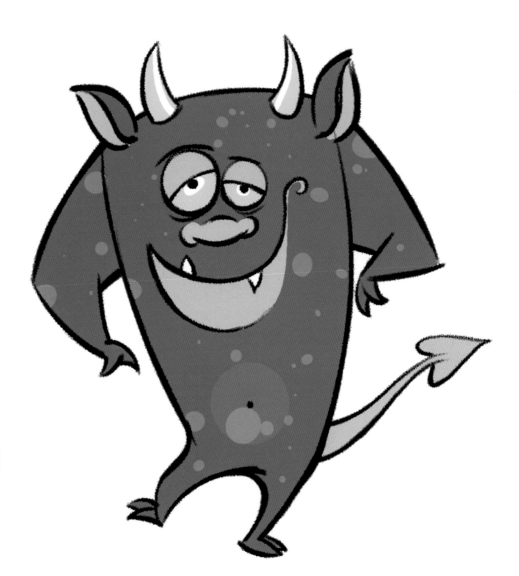

9 **Add Color**
Make your monster any color you like. Disco Devil has been dancing for a while, and it looks like he'll never stop.

Batboy

What collection of monsters would be complete without a bat in the mix?

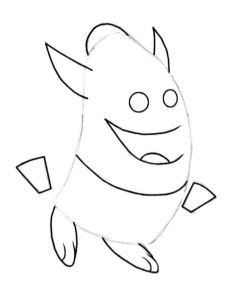

1 Draw the Body Shape

Draw a jelly bean shape with a flat bottom. The top of the jelly bean is slightly pointed on the left side. The bottom is angled high on the left, low on the right.

2 Add Facial Features, Hands, Feet and Hat

Draw two circles for eyes and a wide smiling mouth with a tongue. Add two crescent shapes for pointed ears. Two floating wedge-shaped boxes will form his hands. Draw long ovals attached to his body for feet with curved toe lines and a half-circle for his beanie hat.

3 Develop the Features and Clothing

Draw swooping lines for the outer edges of his ears. Add a triangle nose with a connecting line to his mouth, and add a split in his tongue. Don't forget to add his chin.

Start the wings with crescents on his back. Connect his hands to his body with arms. Throw on a couple of thumbs.

Add a propeller and a stick to his beanie. Add a wide V-shape to the neck of his shirt and cuffs near his wrists.

5 Add the Final Details

Add pupils to his eyes. Draw some tufts of fur on his cheeks and on his forehead. Add a few lines defining the nose (touching the corners of his eyes). Finish the back of his mouth, adding a uvula (the thing that hangs down in the back of the throat).

Add more feathers to his wings. Draw a few lines on his hat, and a button to attach the propeller.

4 Add Face, Hand and Wing Details

Make Batboy's eyebrows with two rectangles. Every bat needs fangs (very important). Add two swoops to his left ear to make them more batlike. Draw a smile line at the edge of his mouth.

Draw two small triangles or rectangles on his hands to make fingers. Add a few feathers to the crescent-shaped wings.

6 Add Color

Add some color with your favorite materials and make Batboy amazing! What would he look like with bat's wings? Try designing a set of bat wings in Step 4 (instead of adding the feathers).

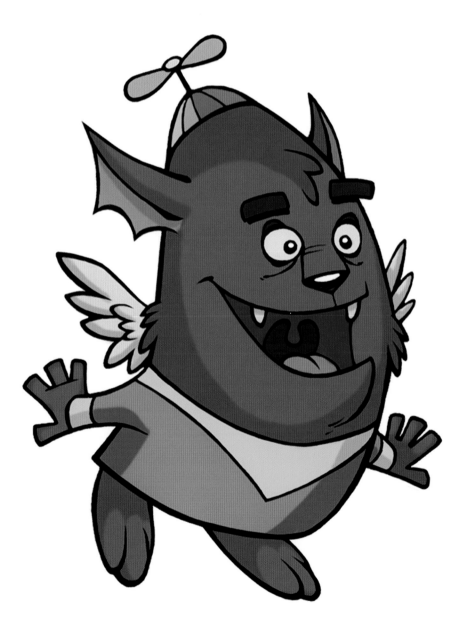

Cutie Pie

Cutie Pie is the cutest thing EVER! But without arms, you'll do all the hugging. Remember to draw lightly at first so you can go back and easily erase lines you don't need.

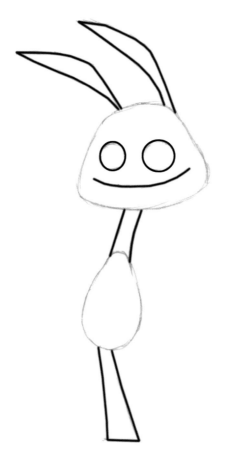

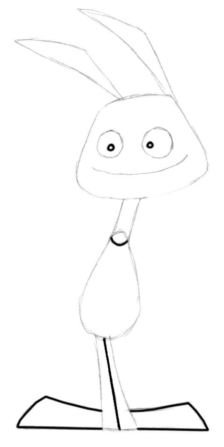

1 Make the Head and Body Shapes
Make a squashed shape for the head. It's like a ball of dough, wide on the bottom, narrower at the top with angled sides.

Leave some space in between, then draw a raindrop with the wide end on the bottom for the body.

2 Add Facial Features, Neck and Legs
Add stretched triangles for the ears. Draw the eyes, making the one on the right larger than the left eye. Add the mouth and neck. Draw the legs with a rectangle shape that is wider on the bottom.

3 Add Pupils, Neck Detail and Feet
Add two smaller circles to the eyes. A circle at the base of the neck shows us where her neck meets her shoulders.

Add a line to divide the legs and form the feet with oddly shaped rectangles.

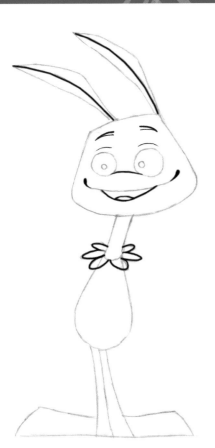

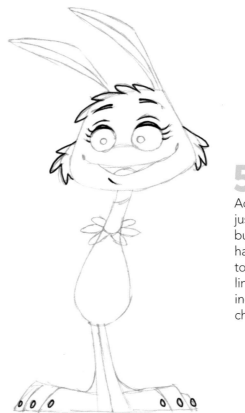

5 Add Hair, Eye and Lip Details and Toenails

Add eyelashes and thicken the line just above her eyelids. Make a few bumps on top of her head for tufts of hair. Add a few more of tufts of hair to her cheeks. Draw a simple angled line for her lower lip. Use a line to indicate where the shadow under her chin will be. Add tiny little toenails.

4 Add Face Details and a Collar

Draw eyebrows and a few rounded lines just above her eyes. Add more detail to her ears. Draw a mouth shape (to open her mouth), and turn up the corners of her smile. Add a tongue. Use a rounded line to show where her nose is. Add the flower collar at the base of her neck.

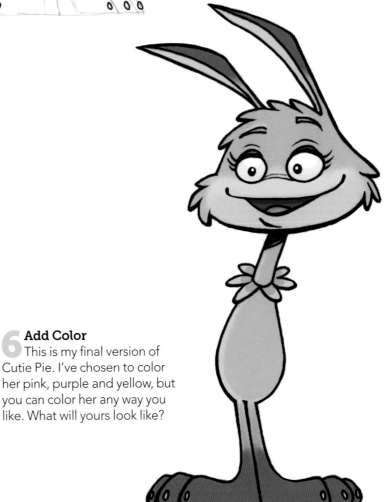

6 Add Color

This is my final version of Cutie Pie. I've chosen to color her pink, purple and yellow, but you can color her any way you like. What will yours look like?

Recliner

This guy is a monster's pet, similar to a dog. Maybe he fetches the *New Monster Times* newspaper from the monster paperboy, or chases away any would-be burglars and mail-delivery monsters.

1 Draw the Body Shape

Draw a triangle with a flat bottom. The top of the triangle is right of center, and the angles are slightly curved. Notice how the base of the triangle extends past the right side of the triangle.

2 Add Facial Features, Feet and Rear

Draw two circles for eyes, making the left eye bigger. They sit to the right and low in the center of this beast. The shape of his eyebrow is like a stretched lowercase n.

Place the wide mouth low on his head, breaking the boundary of the triangle and curling under. Note that the line at the left edge of his mouth turns down just slightly.

Add two lumps (his feet) very close to each other. Make a stretched bump to form his rear.

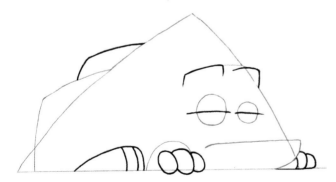

3 Shape the Eyelids, Eyebrows, Toes and Second Hump

Give your Recliner eyelids. Each of the lines cuts the circle of his eye exactly in half. The lines also break outside the edge of the circles. He has two eyebrows, so separate the eyebrow shape.

Add toes to his front feet, dropping below the horizon line that the body is sitting on. Add toes to the other two feet that you can see.

Draw another hump shape on his back.

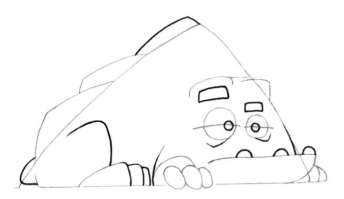

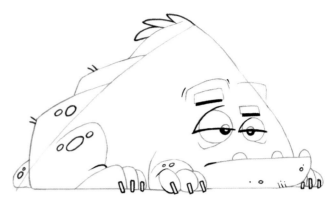

4 Develop the Personality
At this stage you'll start to develop the Recliner's personality. Add circles for pupils. They sit on the eyelid line, close to each other but not close enough to make him look cross-eyed.

Add rectangle-shaped eyebrows. One is bigger and higher up on his forehead. (This, combined with the eyelids we'll add in Step 5, will make him look like he's just waking up.) Draw bags under his eyes; this will add to the feeling of his being confused.

Draw a line that describes the bunched-up muscles of his forearm and another for his hind leg. Add a funny little nub of a tail. Can you picture him trying to wag it?

5 Add the Final Details
These final details will really bring your Recliner to life. Add three little tufts of hair on his back. Then add toenails and spots on his back, rear flank and tail.

Blacken the bottom half of the pupils. Draw a diagonal line on the left side of both of his eyes to flesh out his eyelids. This will add to the effect that he's just waking up because he heard something we can't see.

6 Add Color
Now add some color, and you've got yourself a reclining monster. What woke him up? Add it to your drawing of the Recliner. I'd love to see what you come up with. How could you change his expression to surprise, anger, sadness, happiness?

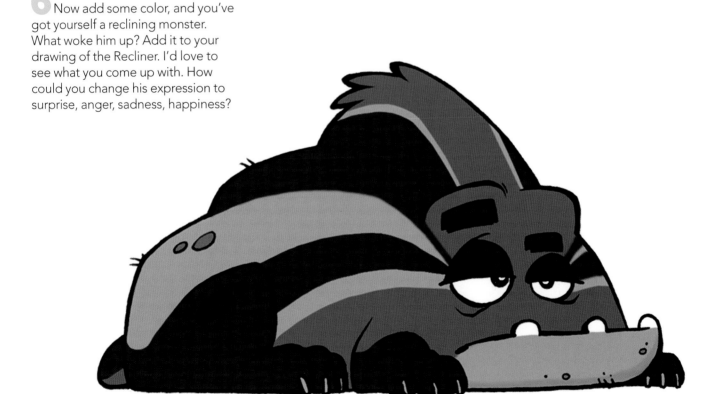

Dewobble

Dewobble wants to play, but first you've got to draw him. Attaboy!

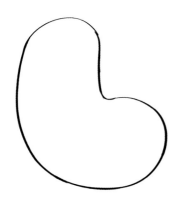

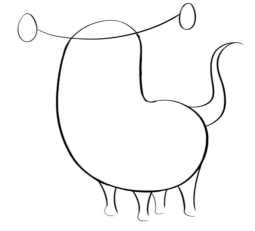

1 Start the Body
For every scary creature, you have to have a cute one. Start this cute monster by drawing a really fat L-shape.

2 Draw the Eyes, Tail and Legs
Add a line that goes through the top of the L and add a circle at each end for the eyes. Add a tail on the back and some lines under the body for the legs.

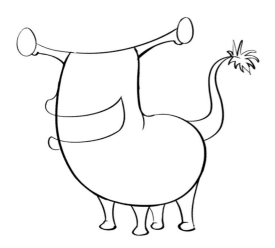

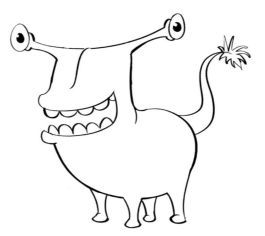

3 Add More Features
Add connecting lines for the bottom part of the antennae that connect to the eyes. Add a mouth and some little hands and feet. Don't forget to add a cute fuzzy puff of hair at the end of the tail.

4 Clean Up and Finish the Eyes and Teeth
Clean up your lines, add some details to the eyes and eyeballs and teeth to the mouth.

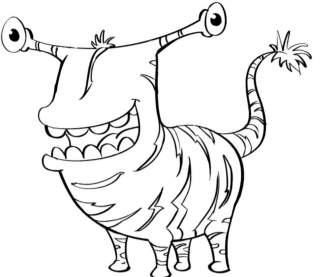

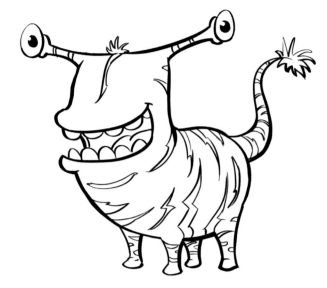

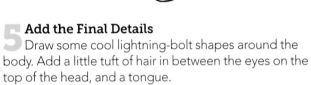

5 Add the Final Details
Draw some cool lightning-bolt shapes around the body. Add a little tuft of hair in between the eyes on the top of the head, and a tongue.

6 Finish the Mouth and Clean Up
Clean up and add weight to your lines, then add some more detail to the mouth and get ready to color!

7 Add Color
Use any colors you like for your monster. I thought the purple was super cute and could imagine this monster running around in the backyard playing fetch and coming up to lick your face. Yuck! Cute … as long as it is licking someone else's face.

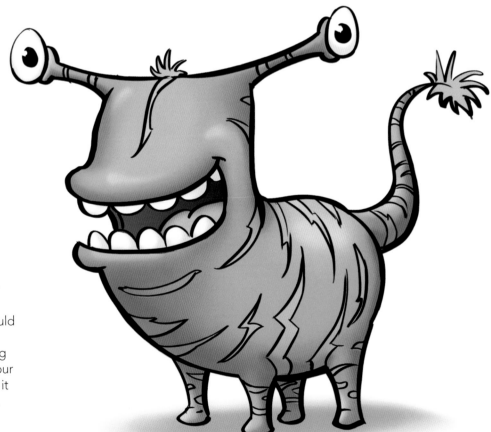

Redomo

Yikes! Sharp teeth, spiky hair and sharp claws are all signs that Redomo is ready to bite you and scratch your eyes out. Draw him if you dare.

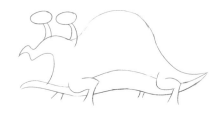

1 Draw the Basic Shapes
Draw a circle in the middle of the page, then draw a giant mustache shape connected to the bottom of the circle.

2 Form the Backside, Head and Legs
The top of the circle forms the middle of this creature's back. Draw a line from the circle to the tip of the mustache on the right side to form the backside of the monster. On the left, draw a set of wavy lines to form the head and open mouth. Now add some legs on the near side.

3 Clean Up and Add Eyes and More Legs
Erase the inner part of the circle, and add some awesome snail-like eyeballs coming out of the head. Now add some lines on the bottom part of the body for the legs on the far side of the creature.

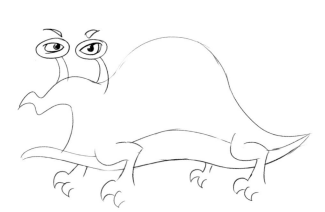

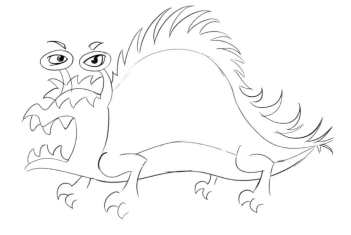

4 Draw the Eye Details and Toes
Add some cool eyeballs, eyebrows and some toes.

5 Add Hair and Teeth
Next, add some cool hair along the back of this creature, coming down onto his face in between his eyes. Add some scary sharp teeth.

6 **Complete the Toes, Mouth and Belly**
Finish off the toes and mouth features and add some curved lines along the belly.

7 **Ink the Drawing**
Go over your drawing with a pen to create darker lines.

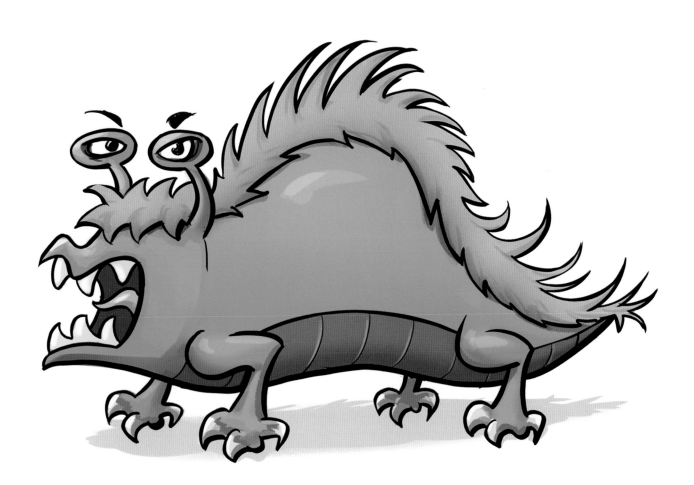

8 **Add Color**
Color your creature with your favorite materials. Redomo looks pretty scary, but I know from personal experience that giving him a snack and rubbing his belly will make him purr like a kitten.

Bull-Ony

Bull-Ony was the most popular attraction at the weird and wonderful circus. Start drawing to add him to yours!

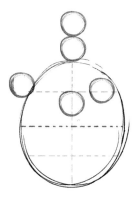

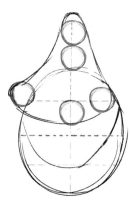

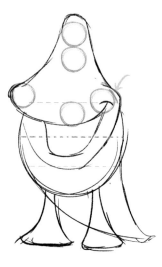

1 Start the Head
Draw an oval for the head with three guidelines dividing the oval into four sections. Stack two small circles on top of the oval to mark the top of the head where the eye will go. Place two small circles inside the oval and one just to the left of the circle to mark the curve of the nose.

2 Connect the Circles
Draw a line around the outside of all the smaller circles. Start by connecting the small circle on the right to the small circle on the left (this becomes the front of the nose). Now continue that line around and over the top circle (creating the top of the head).

3 Add Face Details, Legs and a Tail
Add an inner line for the inside of the mouth and add a little cheek and finish off its smile. Add some stubby legs (they kind of look like giant chocolate chips) and a tail.

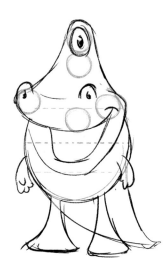

4 Add the Eye, Nostrils and Arms
Add a big eye toward the top of the head. Give this monster some nostrils and arms.

5 Add Horns and a Chicken Comb
Add some cool horns and a crazy-looking chicken comb (that red thing on top of a chicken's head).

6 **Finish the Mouth**
Add some fun rounded teeth and a tongue to the mouth.

7 **Clean Up and Ink the Drawing**
Tighten up your drawing and ink the final lines with a pen.

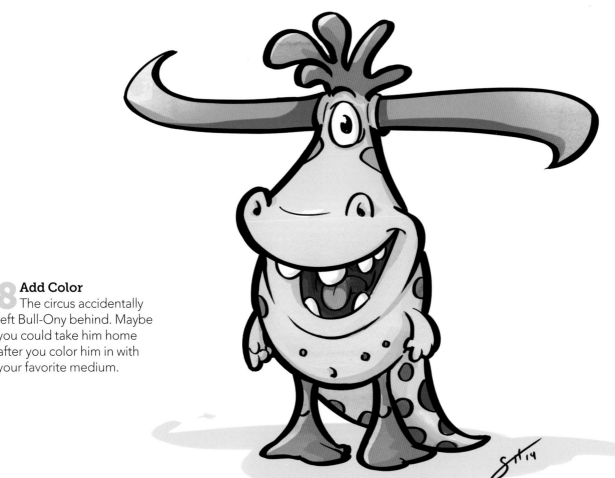

8 **Add Color**
The circus accidentally left Bull-Ony behind. Maybe you could take him home after you color him in with your favorite medium.

Antlerpillar

Antlerpillar is kind of like a caterpillar with antlers, but, with those sharp teeth, I'm sure he doesn't eat leaves.

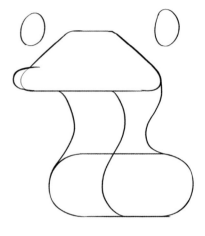

1 Draw Circle Guides
Draw three circles as guides for placing the main head and body shapes.

2 Draw the Head and Body Shapes
Draw a rounded trapezoid for the head and an extended circle for the body.

3 Connect the Shapes and Add the Eyes and Nose
Draw three backward S-curves to connect the head and body. The left two S-curves are almost identical, while the right one curves in the opposite direction. Add two eye shapes and extend the left part of the trapezoid to create a nose shape.

4 Develop the Belly, Jaw and Antennae
Add some curved lines along the belly and a shallow curve for the bottom of the jaw. Add the beginnings of some antennae.

5 Develop the Features and Add Arms and Legs
Add a smile. Connect the eyes to the body. Add the inner part of the antennae and some little arms and legs.

6 Add Eye and Antenna Details
Add some claws on top of the antennae and add some eye detail.

7 Add Teeth and Texture
Add a couple of monster teeth and some cool shapes along the body to give this monster some texture.

8 Add Color
Have fun and color with your favorite materials! If Antlerpillar made a cocoon, would he metamorphose into a deer fly?

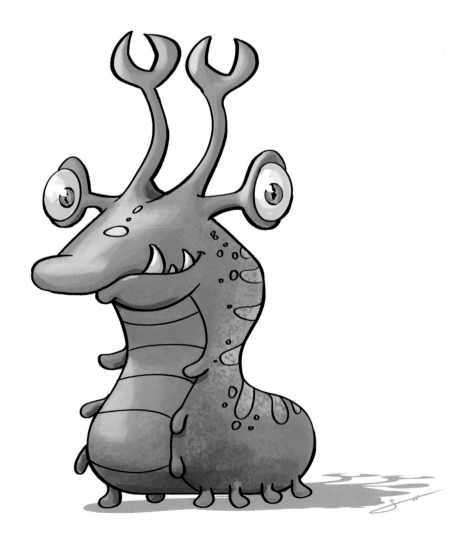

4 ALIEN MONSTERS

Ernie, Ken and Scott have explored the outer reaches of their minds to invent some really spaced-out creatures. The monsters in this chapter are intergalactic-fantastic! Full thrusters to warped-out imagination!

Octo

Octo's snakelike limbs are crawling to get your attention.

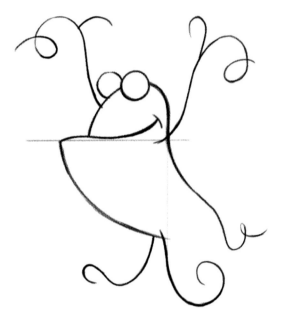

1 Start the Body, Smile and Eyes
Lightly sketch a right angle, then draw in two curves as shown. Finish the smile that almost touches the back of the head. Draw two circles for the eyes.

2 Start the Tail, Arms and Legs
Extend the tail with a loop and draw in four curvy lines for arms and legs.

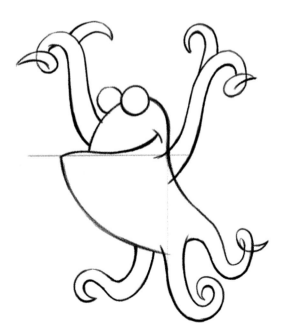

3 Finish the Tail, Arms and Legs
Finish the arms, legs and tail by starting wide at the base and tapering to the ends.

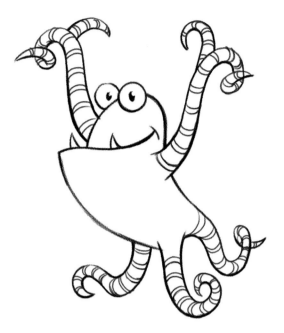

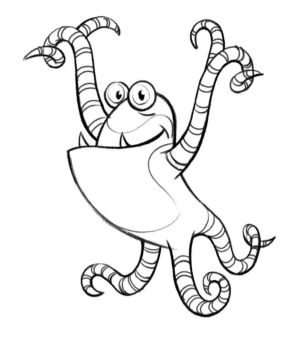

4 **Add Stripes, Pupils and Teeth**
Erase all the overlapping lines and draw bands on the snaky tentacles. Add two pupils with highlights and two teeth.

5 **Add the Final Details**
Lightly draw in the irises. Add a line to separate the front of the body from the back.

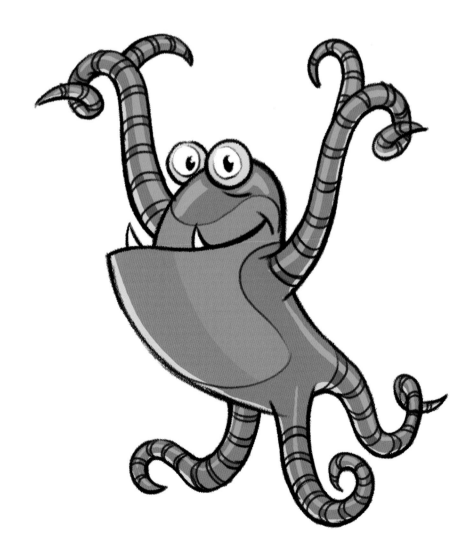

6 **Add Color**
Color it all in and use a different color for its face and tummy. Did Octo's wavy arms get your attention?

Crickie

Crickie is a tough little alien who is daring you to draw him. Will you show him that he's not that tough to draw?

1 Start the Head and Body
Lightly draw a medium-sized circle and a smaller tilted oval below.
Draw the shape of the head by extending the shape of the circle. Note that the top of the extended shape curves down farther than the bottom curves up.

2 Connect and Add a Tail
Erase the right side of the circle. Connect the two shapes and add a tail. Note how the top right side of the oval is cut into by the new line.

3 Start the Horns and Facial Features
Erase the unwanted portions of the lower oval. Draw the two horns and a long frown. Lightly draw an eye line in the shape of a smile beneath the horns.

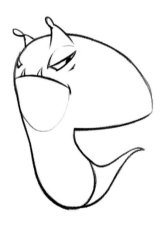

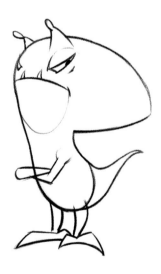

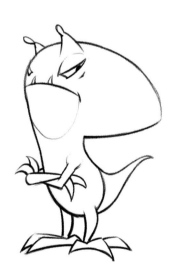

4 Add Facial Feature Details
Draw the slanted eyes, pupils and eyelid accents. Erase the line behind the horn. Add the teeth and chin line.

5 Add Arms and Legs
Draw the arms and legs with simple lines and shapes.

6 Finish the Feet, Claws and Arms
Finish drawing the feet, claws and left-side arm. Erase the body lines behind the arms and legs.

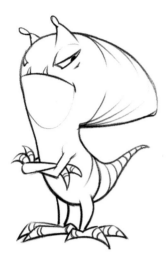

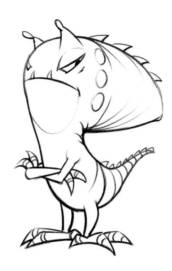

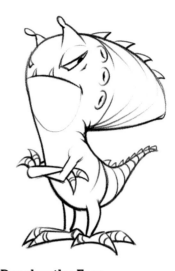

7 Add Stripes
Add stripes to the tail, hands, claws and around the back of the head.

8 Add Spines, Wrinkles and Ears
Draw triangular spines on his head and tail. Add wrinkles to his neck and three oval ears.

9 Develop the Ears
Erase the front side of each ear and add an inner-ear shape.

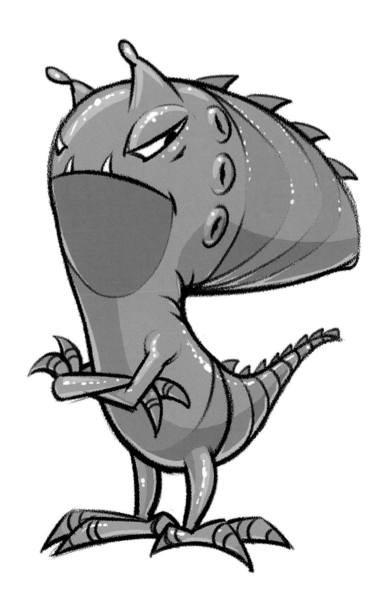

10 Add Color
Use your favorite materials to color it all in. The little white highlights give this cricketlike creature a shiny wet look.

Squiddie

This happy little squid would swim across the galaxy just to make a friend on Earth. Are you ready to make Squiddie with your pencil?

1 Start the Body and Feet
Draw an elongated toothlike shape. Draw a light line horizontally across the middle of the body for a guideline, and add two short tentacle feet.

2 Draw the Mouth and Chin
Draw a mouth and chin. Note that the lips are outside the tooth shape, and the smile reaches the halfway line.

3 Start the Eyes and Arms
Erase the halfway guide. Draw two circles for eyes and two tentacles for arms.

4 Clean Up and Add the Teeth and Tongue
Erase behind the eyes, arms and lips, but leave a short segment in his mouth shape. Draw triangular teeth and a tongue.

5 Add Eye and Feet Details and a Third Leg

Draw the center of the eyes and a third tentacle leg. Add eyelids and lines on the feet to divide the bottoms from the top.

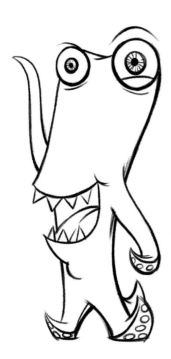

6 Add Final Details and Darken the Lines

Sketch in little ovals for suction cups. Add the irises and darken the outside lines.

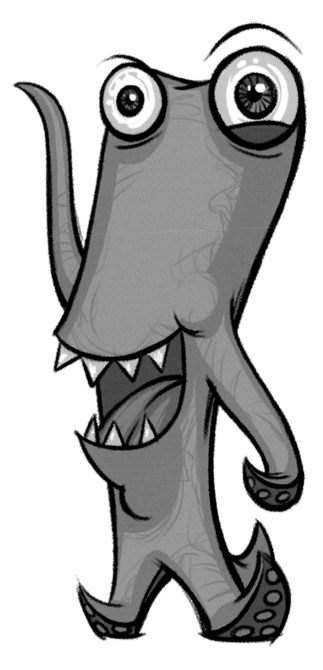

7 Add Color

Color your monster with your favorite supplies. Squiddie's eyes make him look a little crazy, so I wouldn't let him get too close. With a mouth that size, he might just swallow you whole!

ALIEN MONSTER • ERNIE HARKER

Pigworm

Her short tentacle "hair" and lack of teeth and claws make Pigworm friendly enough to pet.

1 Start the Body and Legs
Draw a tall, slightly bent upside-down U-shape. Draw two of her short legs.

2 Start the Facial Features
Draw a wide smile about halfway down the body and add two little dots for eyes.

3 Develop the Facial Features
Add two tiny eyebrows and a three-lumped nose.

4 Clean Up and Add More Legs
Draw three back legs and erase the smile line behind the three-lumped nose.

5 Start the "Hair" Tentacles
Lightly space the bottoms of the "hair" tentacles with hashmarks. Try to make the distance from mark to mark (representing each tentacle) about the same size.

6 Develop the Tentacles
Draw in the shape of the hair tentacles.

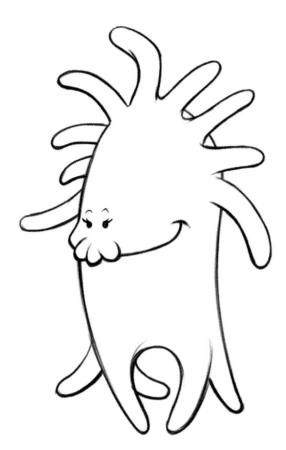

7 Add the Final Touches
Erase the lines of the head behind the tentacles and add lashes.

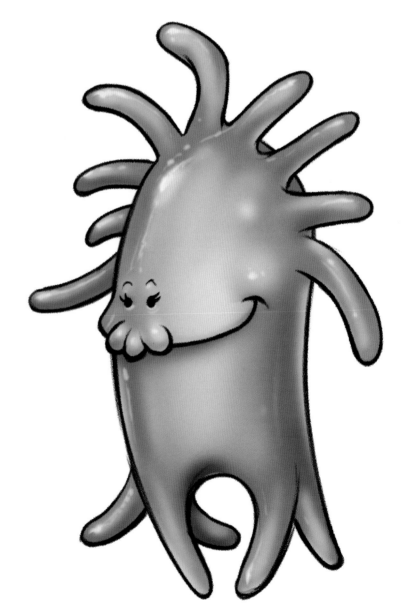

8 Add Color
Add color with your favorite materials. Go ahead and pick up little Pigworm. She is filled with a tickly jelly that will make you smile.

Hoppy Slug

This goofy little guy can't wait to get started.
He's so excited that he's jumping off the page!

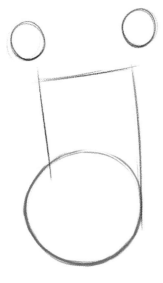

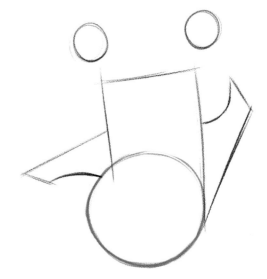

1 Start the Body and Eyes
Lightly draw a large circle for a tummy shape, a rectangle that lines up on the right side of the circle and two circles wide apart above for eyes.

2 Add the Arms
Draw in two shapes for arms.

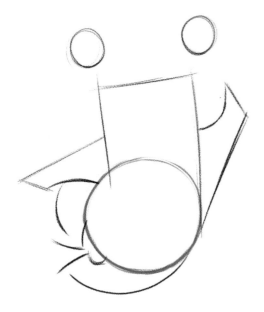

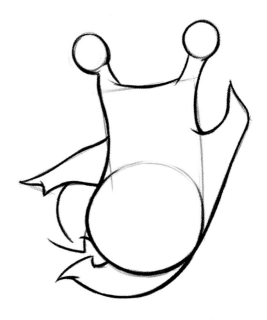

3 Add the Legs
Draw two shapes for the legs. Notice how the leg on the left starts near the wrist of the arm on the left.

4 Connect the Shapes
Connect all the shapes and darken the lines.

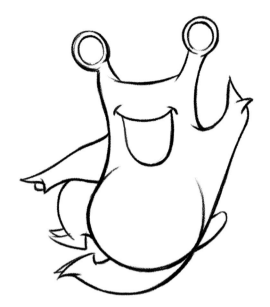

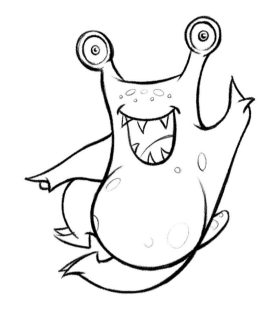

5 Add More Details
Erase the unwanted guidelines and add eyeballs, fingers, toes and a tail. Draw in a big smiling mouth.

6 Add the Final Details
Add the teeth, tongue, middle of the eyes and oval spots.

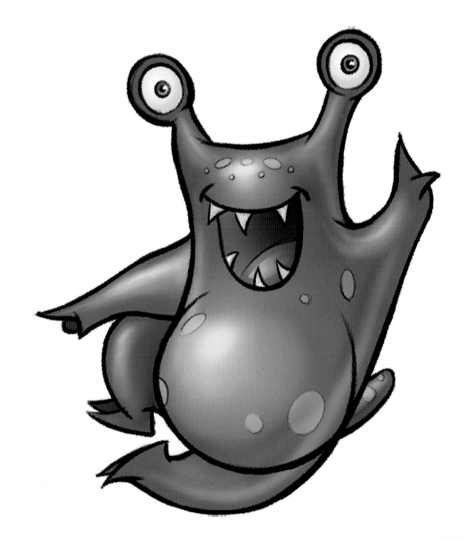

7 Add Color
Color your monster however you like. Great job! Hoppy is so happy he could hop!

ALIEN MONSTER • ERNIE HARKER

Pinhead

This armless monster is called Pinhead because he looks a lot like a bowling pin with eyes.

1 **Start the Body Shape**
Begin by drawing a bowling pin shape that flares out at the bottom.

2 **Add the Shorts and Legs**
Add shorts to the bottom of the bowling pin. Draw two wormlike legs.

3 **Start the Eyes**
Draw a large circle at the top of the head and smaller ones on each side.

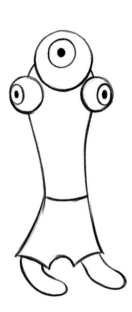

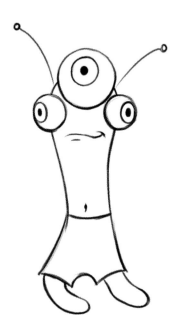

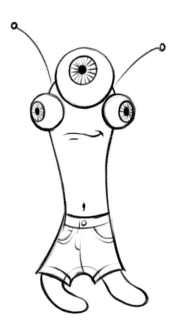

4 **Add Irises and Pupils**
Erase the lines behind the eyes and draw the irises and pupils of the eyes.

5 **Add More Features**
Add antennae, a smirk and a belly button.

6 **Finish the Eyes and Shorts**
Draw the details of the eyes and the shorts.

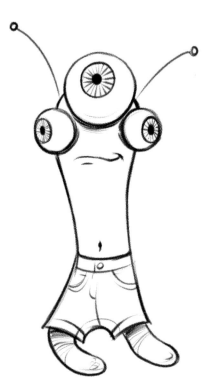

7 Add Shading
Add shading below the eyes and on the legs below the shorts, and he is ready for color.

8 Add Color
Use your favorite art supplies to add color. Please don't knock Pinhead down. Without arms, it's very difficult for him to stand up after he falls.

Leggs

Leggs lives in a world where his species' most dominant feature is their mouths. I wonder what Leggs would eat? Slow-moving, jumbo alien marshmallows? What do you imagine he would eat?

1 Start the Body and Legs

Draw an oddly shaped oval. It's wider than it is tall and has almost an onion shape with a point on top. Add two short rectangles to the underside.

2 Start the Facial Features, Feet and Knees

Add two eyes, making the right eye a bit larger than the one on the left.

Draw a wide mouth. The line for his mouth breaks through the line of his body, then slopes under to connect with his chin.

Add two lumpy half-circles for feet. Draw a light line horizontally across the middle of the feet shapes to mark where his toenails will go.

Add an L-shaped knee to the right of his mouth and one beneath his chin.

3 Add Markings, Toes, Tail and Fur

Add a patch over each eye to make his eyes pop.

Draw three slash marks on his leg, following the bulge of his big leg muscles. You'll see that I decided to eliminate the top slash in my final drawing (see Step 5). You can keep it if you want to.

Draw the toes directly under the line from Step 2. On his left foot, two of his toenails overlap slightly. This gives the illusion that the foot is rounded, and the shape is moving around to the other side of his foot.

Add a candy-cane shape to the back of his right leg. Draw a little tail and a crest of fur on his upper back.

4 Add the Final Details

Draw two rectangular eyebrows. Then add two fangs and a dimple in the corner of his mouth.

Draw a patch of color on his chin and eight little spikes to make him look a bit more menacing.

Add a wrinkle on the top of each foot where it meets the leg.

5 Add Color

What colors will you make your Leggs monster? What would he look like with his mouth open? Experiment with your favorite materials. Look at real live animals. What do their mouths look like as they stretch when they yawn? How does the shape change? Make some amazing artistic discoveries. Draw two of these monsters and you'll have a pair of Leggs. Get it?

ALIEN MONSTER • KEN CHANDLER

Sharkmole

I love the odd look of the hammerhead shark, with its eyes wide apart on its head, and something about a mole's claws intrigues me. It allows them to dig quite fast. What if a monster had the ferocity of a shark, and the digging power of a mole? He'd be … Sharkmole!

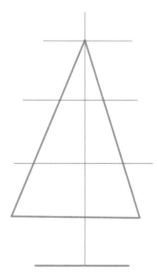 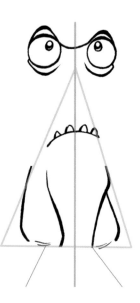 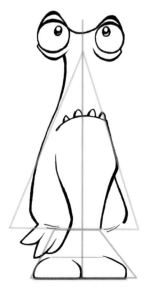

1 Start the Body
Draw a tall vertical line and a triangle. The triangle is a bit wider on the left side than on the right.

Draw a line across the top of the triangle. Then draw two lines about equal distance from each other so that the triangle is divided into three equally spaced sections. Draw a line at the bottom for the Sharkmole to stand on.

2 Add the Eyes, Mouth and Arms
Draw two eye circles for eyes on the top line. Draw a curved line to connect the tops of the eyes. The mouth sits just below the second line down. It dips heavily on the left side. His arms sit in the bottom two-thirds of the triangle and extend into its middle.

3 Add More Features
Give Sharkmole pupils, brows and bags under his eyes. Four teeth are spaced out over the line that makes the mouth. Next, draw a trapezoid below the triangle as a guide for the legs and feet.

4 Add Arms, Claws and Feet
Draw a line from the left arm, up the left side of the triangle, then swoop up to connect to the right side of the left eye.

Add mole claws. The pinky is at a hard left angle where the left arm ends. Draw a half-circle for each foot.

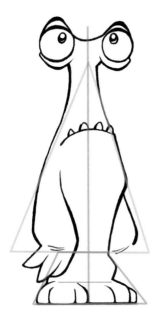

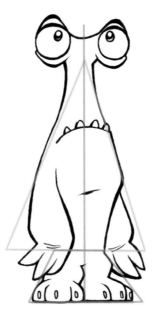

5 **Finish the Left Side and Start the Right Side**

Add toes, a bent knee and a line to connect the left foot to the middle claw.

Now focus on the right side of Sharkmole. Follow the line of the triangle up to the level of his right eye, then sharply angle out to connect with the lower left side of the eye.

6 **Add the Final Details**
Finish Sharkmole by adding a line that describes the left leg with a bent knee. Draw a line below the rib cage. Add claws to the toes.

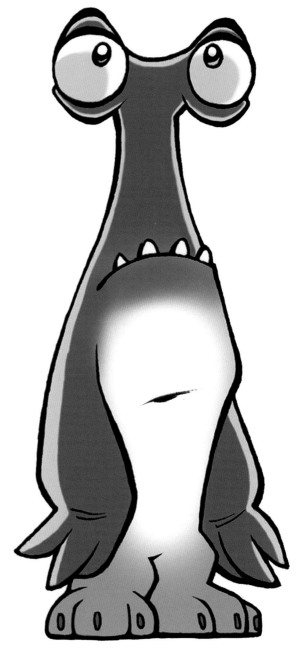

7 **Add Color**
Erase the guidelines and color with your favorite supplies. Sharkmole lives on a planet where things often fall from the sky. His eyes are always looking up, and his claws are ready to dig his way to safety.

Alien Puppy

Puppies are fun no matter what planet they're from. This is my version of what a puppy would look like if it visited from a galaxy far, far away.

1 Start the Body and Head

Draw a horizontal line at the bottom for the ground. Lightly draw a vertical guideline from the center of the horizontal line. Draw a tall leaning rectangle with an angled shape on top. The vertical line touches both of these shapes on their corners. Note how the top left corner of the leaning rectangle and the bottom left corner of the shape on top intersect with the guideline.

Draw an eye circle on the right side of the top shape. It should break out of the shape.

2 Add the Antennae, Eyelid and Mouth

The antennae are two very thin stretched rectangles. The right one is bent near the middle.

Draw a slightly curved line horizontally through the eye. Draw a short diagonal line below the eye as a lower eyelid.

Add a little bump for the lower lip. Draw a big smile from the lower lip, dipping below the line between the head and body shapes, then rising again. Add a smile line at the corner of the mouth.

3 Finish the Facial Features and Add Feet

Draw a circle for the pupil, leaving a small highlight. Darken the space directly above the eye, then draw a big friendly eyebrow. Draw three goofy looking teeth.

Draw three rough half-circles for the feet. The far right foot is on the horizontal line. The other two feet dip a little below that line.

4 **Add the Toes, Spots and Tail**
Add toes to the feet. Make three lumps where the leg muscles get bunched up when he sits. Draw some spots or design your own pattern. Start the tail.

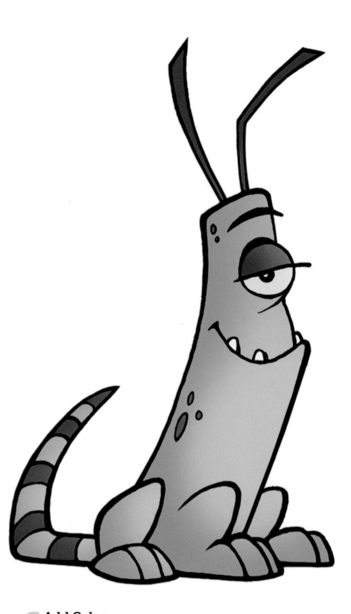

5 **Finish the Tail**
Extend the tail into a long whippy tail. It's angled at the bottom, then it really bends.

Add stripes. Draw the stripes with a little bend in the line to give the tail the illusion of roundness.

6 **Add Color**
Color with your favorite art materials. Give Alien Puppy a name. Every dog needs a name. What would he look like with his mouth open? Does he have a big tongue for licking people? Does he have two tongues? Does he have any alien superpowers? What will you come up with?

IndyMelon

IndyMelon is a mysterious alien living on the innermost of Jupiter's moons. This gigantic monster is fifteen feet (4.6m) from head to tail and feeds on volcanic ash. Don't be fooled by its tiny wings, because it can quickly attack without warning. The IndyMelon's tail is a violent whip and may be poisonous! We don't know how it lives since it has attacked and eaten every space probe that has landed on its moon.

Draw each step light and loose and we'll tighten it all up at the end.

1 Start the Body Shape
Draw a series of three circles. The top two are within each other and the third is underneath those.

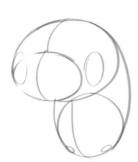

2 Develop the Body
Connect the circles to form the body. Draw a center line along these shapes. Add some little circles on the very bottom to show where his legs will come out and add two medium-sized ovals to show where the arms will come from.

3 Add the Tail, Wings, Eyes, Arms and Legs
Draw a cool tail coming out the bottom, swooping down and away from the body. Add some wings. Draw two ovals coming out the top of the head for insect eyes. Add some arms and leg shapes.

4 Develop the Wings, Arms and Tail and Add a Pincer
Draw some shapes around the wings to show movement. Add finger shapes. Add oval shapes to the elbows. Add some fur at the end of the tail. Most importantly, add a pincer shape coming out of its head so we know it is some kind of insect creature.

5 Add the Final Details

Add fuzzy shoulders and details to the eye, back and mouth.

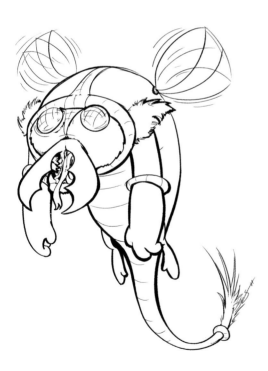

6 Ink Over the Drawing

Draw all the details with an ink pen and erase your pencil sketch.

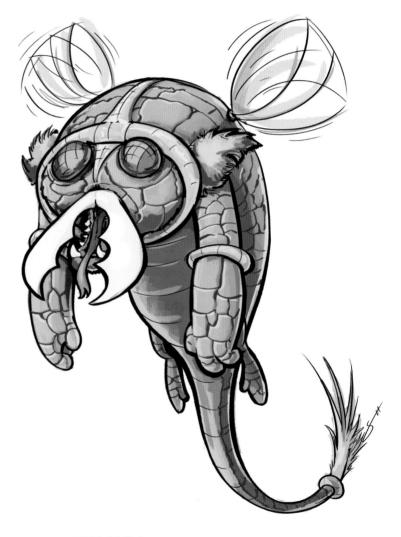

7 Add Color

Have fun and color. Since this alien eats volcanic ash, add some cracks on its skin, giving it a hard-shell look.

5 MONSTER MASHUPS

What would happen if you were able to mix the genetic material of a fish with a cat? It would certainly be the strangest catfish ever created. In this chapter we'll take familiar animals and mix in different features to invent some very interesting monsters.

Dumbopus

Dumbopus is a monster created by mixing an elephant with an octopus. I love his great big cute fish eyes and his little octopus tentacles!

1 Start the Body and Eyes
Draw a large circle and lightly draw straight guidelines through the middle, top to bottom and side to side. Draw two circles for eyes.

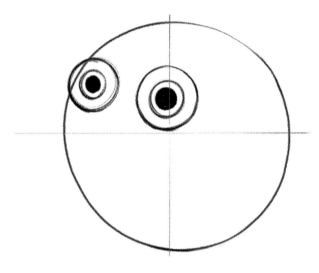

2 Add Pupils and Irises
Draw the pupils and irises of the eyes.

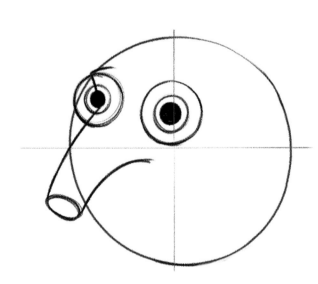

3 Start the Nose
Draw a tubelike nose with an angled eyebrow ridge.

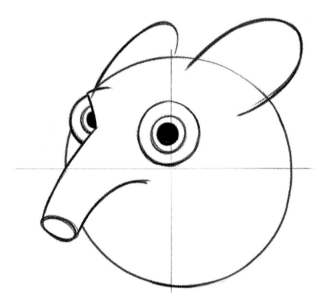

4 Clean Up and Start the Ears
Erase the lines you don't need. Draw two big upside-down U-shapes for ears.

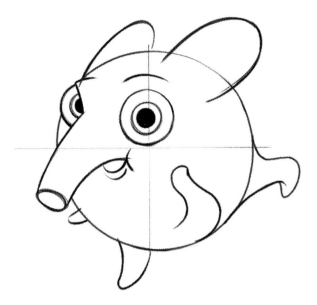

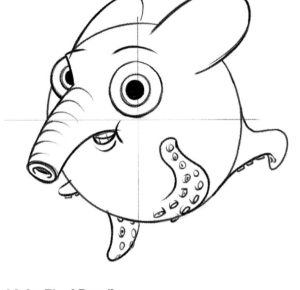

5 **Add the Eyebrow, Smile and Tentacles**
Add an eyebrow and a smile. Draw four tentacles.

6 **Add the Final Details**
Add the teeth, nose ridges and suction cups on its tentacles.

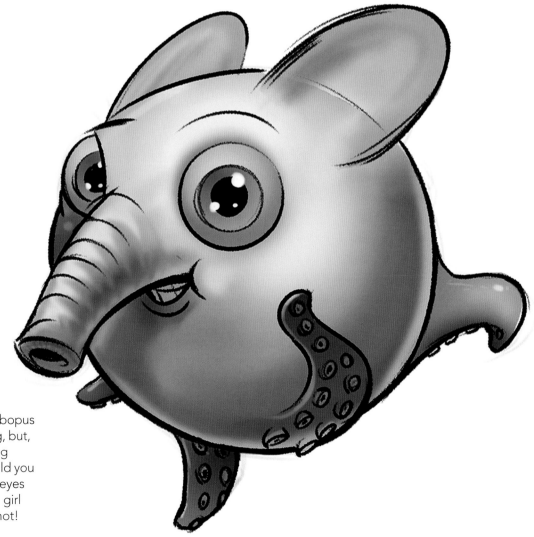

7 **Add Color**
I can't tell if Dumbopus is flying or swimming, but, either way, he's saying goodbye. What would you add to Dumbopus's eyes to make it look like a girl monster? Give it a shot!

Tri-Goat

This little goat is actually a goat and a half. Something happened in the cloning machine, and he ended up with an extra eye and horn. Draw each step light and loose, and we'll tighten it all up at the end.

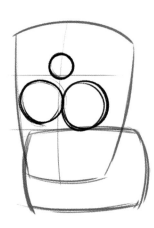

1 Start the Head
Lightly draw a rectangle that is tapered at the bottom. Lighter still, draw a slightly curved vertical line down the middle. Then divide the body horizontally into equal thirds.

Goat Doodle
Sometimes I scribble around to see what I can come up with. Tri-Goat started with a doodle that looked like this.

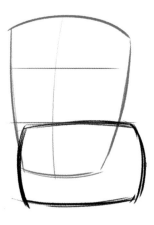

2 Start the Body
Lightly draw another bulging rectangle lengthwise. The top of the new rectangle is in line with the lower third of the first rectangle and extends to the right.

3 Start the Eyes
Lightly draw three circles for eyes.

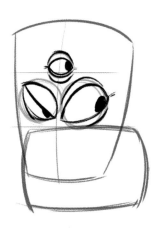

4 Add the Eye Details
Define the almond shape of the eyes including eyelids and pupils.

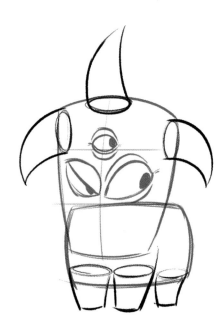

5 Add the Horns and Legs
Lightly draw in three curved cones for horns and three tapered cylinders for legs.

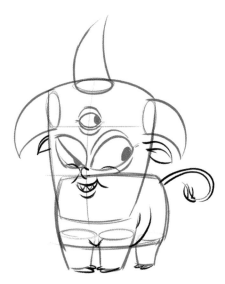

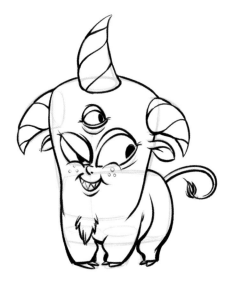

6 **Add the Facial Features, Tail, Tummy and Feet**
Add the ears, nose, cheeks, mouth, tail, tummy and feet.

7 **Darken the Lines and Add the Final Details**
Darken all the lines and add the details of spirals on the horns, freckles, beard and hair at the end of the tail.

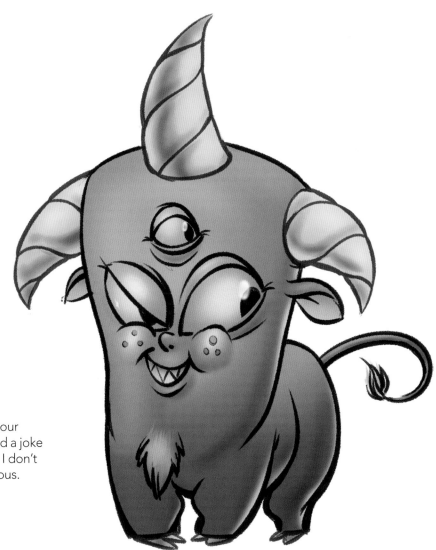

8 **Add Color**
Use your favorite supplies to color your monster. Tri-Goat looks like he just played a joke on his friend Rant (you'll meet him next). I don't know what it is, but Rant sure looks nervous.

Rant

Rant happens when you mix up a batch of ant sauce and rat poison. He's fast and creepy, but definitely more scared of us than we are of him.

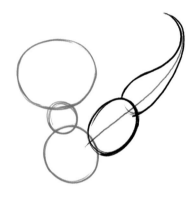
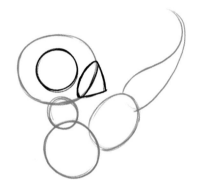

1 Start the Body and Head Shapes
Very lightly draw a straight line slightly leaning to the left. Then draw three overlapping circles as shown.

2 Start the Tail Shape
Next, draw a very light line for the center of the tail. Then draw an oval for the base of the tail and a curved teardrop shape.

3 Add an Eye and Beak
Draw a large eye in the center of the top circle, then draw a stubby cone for a beak.

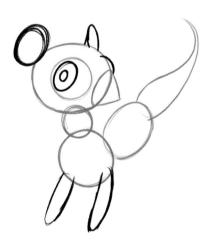
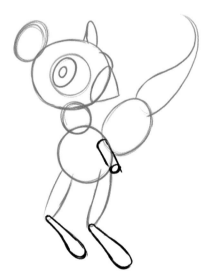
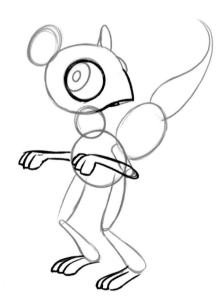

4 Add the Upper Legs, Ears and Eye Details
Add leg shapes, oval ears, oval irises and pupils and a small arc for the right eye (the rest of the eye is almost completely hidden by the face).

5 Add the Lower Legs and Upper Arm
Add the lower legs and a thin cylinder for an upper arm. (The other upper arm is hidden by the body.)

6 Define the Facial Features and Add Forearms, Paws and Feet
Darken the outside of the eye shape, define the beak, and add forearms, paws and fingerlike feet.

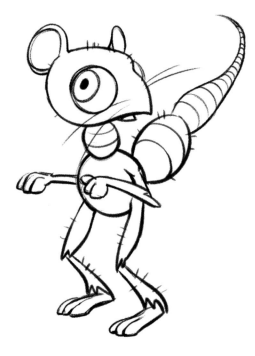

7 Darken the Lines and Add Final Details

Darken all the shapes while adding rings around the neck and tail, as well as whiskers, and short spiny fur on his head, legs and tail.

8 Add Color

Color the monster with your favorite art supplies. Adding white highlights makes anything look wet or shiny. I don't know why, but Rant sure looks nervous.

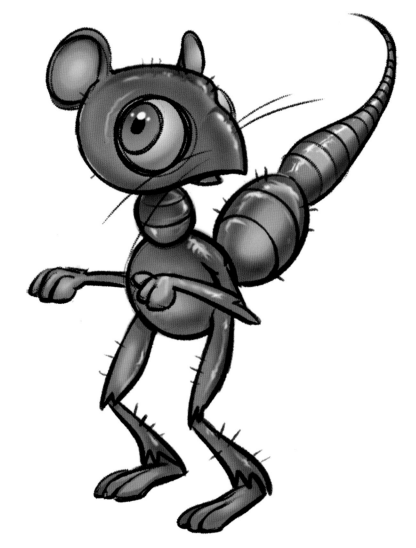

Hammerhead Crab

A hammerhead shark and a crab fell in love in the ocean and had a little baby. He turned out a little crabby and even less sharky.

1 Start the Head and Body
Very lightly draw a triangle that's tipping to the left above a horizontal line that represents the ground. Then draw three ovals that touch the edges of the triangle. The one on the bottom should look like a squished egg.

2 Clean Up and Add a Tail
Erase the triangle guide. Connect the oval shapes and add a tail.

3 Add a Fin and Mouth
Add a dorsal fin to the top of the head and a frowny mouth near the top of the bottom oval.

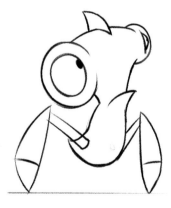

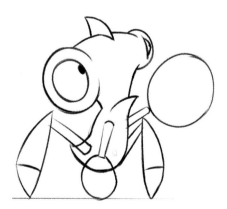

4 Clean Up the Lines
Erase all the unnecessary lines and darken the rest.

5 Add Eyes and Legs
Draw the eyes. Add the large lower legs first so that they touch the ground, then connect the lower legs to the body with thin "upper" legs.

6 Draw the Arms
Add two lollipops for arms. It's OK that the arm on the right is larger than the one touching the ground. Lots of crabs are like that.

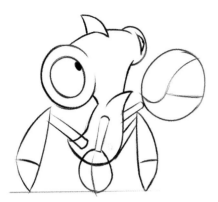 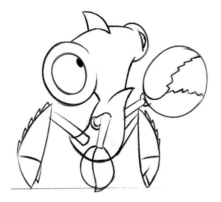 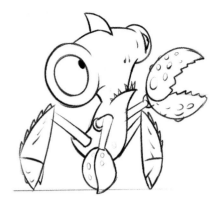

7 Develop the Claws
Divide the smaller claw in half with a curved line and draw an opening in the larger claw.

8 Add Claw Details and Toes
Darken some of the lines and add saw-blade edges to the thick lower legs and the inside of the large claw. Also add some shapes for toes.

9 Clean Up and Add the Final Details
Erase the lines you don't need, then add the teeth, nostrils, bumps on the claws and eye wrinkles.

10 Add Color
Color your monster however you like. Everything about the little baby Hammerhead Crab looks pinchy, pokey, scratchy and uncomfortable. Only a momma crab could love a baby like that!

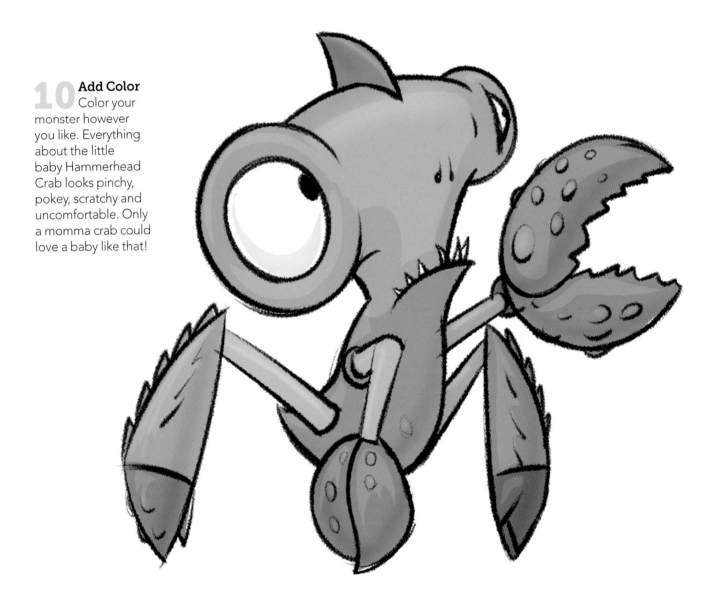

Peeperpillar

Peeperpillar is a cute combination of a caterpillar and parakeet. I wonder what it would metamorphose into if it were to build a cocoon. Would it sprout large feathered wings like a parakeet or butterfly wings?

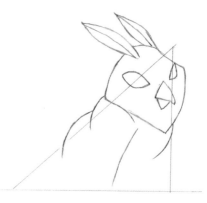

1 Start the Body and Head

Lightly draw a triangle. Make an angled line through the top of the triangle. It should poke out through the line on the left and not touch the line on the right. Beginning on the left side of that line, draw a bulge that rises then descends through the peak of the triangle then curves down to meet the right end of the angled line.

2 Start the Facial Features

Draw two lines on top of the head. Draw two curves for eyes. The right eye curve practically sits on the triangle line. Draw a goofy triangle with soft angles for the beak. Draw two curved lines below the head for a bulging neck.

3 Finish the Facial Features and Body Shapes

Turn the lines on top of the head into feathers. Finish each eye by drawing a line that mirrors the line above it. The right eye curves almost straight out, then angles sharply upward. To finish the beak you started in Step 2, draw another oddly shaped triangle beneath it.

From the cheek, draw a line that angles down into the shoulder. Draw a bulge that rises out of his back and drops through the triangle. In the center of the triangle, lightly draw an angled line. Draw a curvy line on the lower front to finish the belly shape.

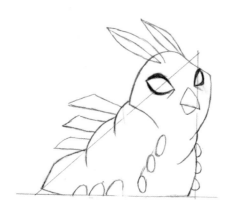

4 Add Eye and Back Details, and Arms and Legs

Thicken the line around the eyes (taper off near the corners). Draw short lines under each of his eyes.

On the back draw three oddly shaped rectangles (forming wings). Finish the tail (its point rests on the triangle).

Draw three half-circles on the rear of the body, resting on the bottom of the triangle, for the leg muscles. Draw three jelly-bean shapes on the angled center line from Step 3. Draw three more jelly-bean shapes on the line of his tummy.

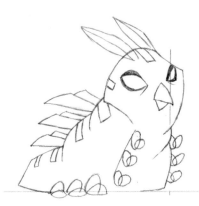 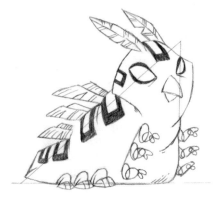

5 Add the Feet, Hands and More Back Details

Add feet to the rear leg shapes. Add six oval hands to the right of the jelly-bean shapes.

On his forehead and along his back, draw six rectangle shapes. Add a second set of rectangle wing shapes on the back, just above the first set.

6 Add the Final Details

Draw toes on the feet (two angled lines per foot). Add two oval fingers on each of the six hands. Then add thumbs on the hands on the right.

Thicken the lines around the rectangles on the back. Draw a few more details in the tail and a shadow under the tummy.

Add simple lines and a few notches to the feathers on the head and the back.

7 Ink the Drawing

Ink in all the details with an ink pen, and erase the pencil lines.

8 Add Color

It's up to you to choose the colors you'll make your Peeperpillar. What would your Peeperpillar look like if it was happy, sad or yelling?

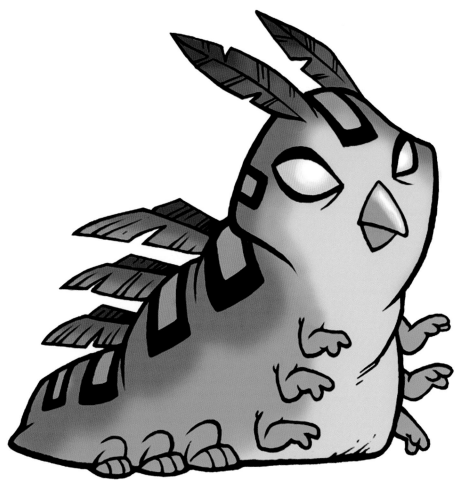

Patience

I've always been entertained by the idea that rocks could secretly be alive. I've also been intrigued by plants, like Venus flytraps that catch and eat bugs. I've combined these ideas into my drawing of Patience. Patience waits patiently for stuff to fly into his mouth for a quick snack.

1 Begin the Body Shape
Draw an oddly shaped rectangle. Note that the top and bottom have a slight curve in the line. The top is narrower than the bottom.

2 Start the Facial Features, Feet and Tail
Draw a circle for the eye and three lines of a rectangle for the mouth. The lines on the right side of the mouth extend beyond the line on the right side of the body.

 Draw two oddly shaped triangles for the front feet. Draw a lumpy circle with an angle on the front for the hind foot. Draw another similar shape behind that to start the tail.

3 Develop the Facial Features, Feet and Tail
Add an eyelid and a circle for the pupil. Using the top and bottom lines of the mouth, connect the top of the mouth to a spot directly below the eye. The lower line is a slight bulge to define the lower lip.

 Add toes to the feet and a little triangle-shaped portion to the tail.

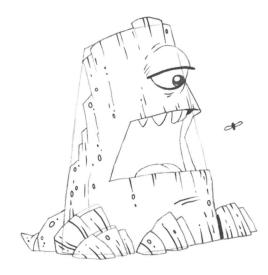

4 Add Face Details and Create Rock Texture

Erase the left side of the eyelid and add three short lines to indicate stretched skin. Draw a line that touches his eye and scoops under to create bags. Add two short lines beneath the eye to emphasize the bags. Add a tongue and teeth (upside-down rounded triangle shapes).

Chisel away some of the stone body to make an angled shape directly above his eye. Make the back into a series of differently sized and shaped rectangles to give the illusion that he's made of stone. Run vertical lines all over him to create rock texture.

5 Add More Texture and a Fly

Add greater detail to the texture of his body. Flying nearby is a delicious fly for him to munch. Note where his pupil is. Is it looking at the fly?

6 Add Color

Color your stone monster with your favorite art supplies. How would you draw Patience if he were covered with moss or made of cotton balls? What if he was covered in soap bubbles? How would you change the shape and texture of his body?

Little Wing

Little Wing is part frog, part lizard and part bird. Odd combination? Little Wing thinks he's perfectly ordinary.

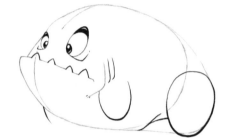
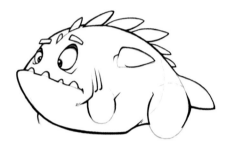

1 Start the Body and Facial Features

Little Wing started out as a little egg in a big pond. So how better to start drawing him than as an oval-shaped egg? (Note: It's resting on its side.)

Draw two tall egg shapes for the eyes. Add two ovals for the pupils and a curvy line at the top of the eye for the eyelids. Draw a guideline on the forehead between the eyes (you'll add spines here later).

Add a rounded V-shape to form the lower jaw and a wide J-shape on the outside of his mouth for the jawline. Draw a line extending from the J-shape (you will draw gills here in Step 2).

Form the hind quarters with a curving line that goes straight out under his belly, then angles up to the curve of his back.

2 Continue Shaping the Features and Body

Start shading the eyes and eyelids. For the lower eyelids, draw L-shapes pointing opposite directions from the bottom of the eyes. Add four stumpy teeth jutting out from the jaw.

Add two J-shaped gills along the short line extending from the jawline. Draw a U-shape for a shoulder, beginning at the jaw and extending beneath the gills.

Draw an egg shape on the hind quarter to form the muscles of the back leg. Draw a short line from the chin to describe another leg.

Draw a curved line like a flattened Y-shape that splits under the body. This shows where the soft underbelly goes under the hard rib cage.

3 Add the Spines, Eyebrows, Wing and Tail

Draw a series of small triangle-shaped spines starting on the line between the eyes and running down the back. Each one gets bigger as they reach the middle of the back and then smaller as they near the tail.

Add rectangle eyebrows and a triangle shape for the little wing. Add a triangular tail.

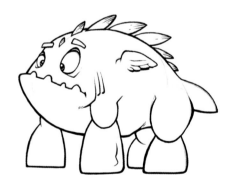

4 Add Detail Lines and Legs

Add detail lines to the spine plates. Add three horizontal guidelines to the wings to start the feathers. Draw a few feathers on the bottom of the wing.

Draw club shapes to block in the legs. Add a squiggly shape for the ankle.

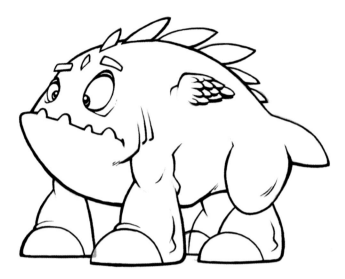 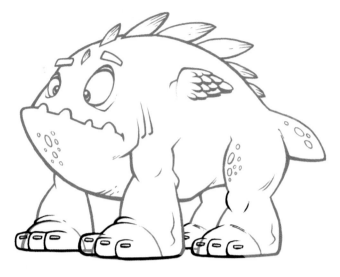

5 Develop the Feet and Wings
Draw half-circles for the feet. Add a wrinkle on the tops of the front feet. Draw a little curved line to describe the arm muscle and elbow joint.

Add more details to the wings, using the guidelines to build the feathers.

6 Finish the Knees and Toes
Draw a kneecap on the rear leg, where the upper and lower leg meet. Add a line to describe the knee's outer edge.

The toes are a series of C-shapes built on the edge of the half-circle feet. Add toenails and you're done!

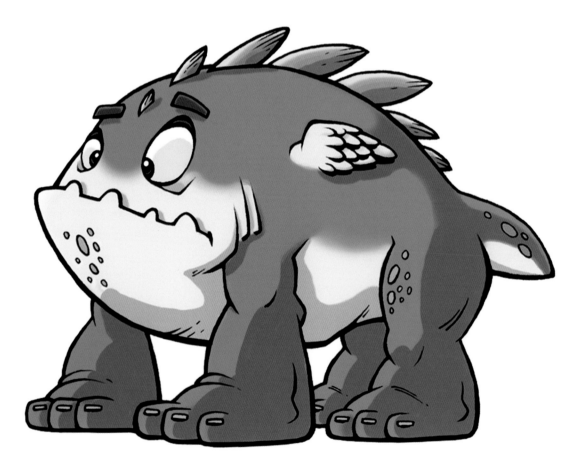

7 Add Color
Color your monster with your favorite materials. That wasn't so hard, was it? Don't answer that. He's got wings, but I don't think they would take him very far.

Doogatormoose

This guy is part duck, alligator and moose. It may be a very strange combination, but Doogatormoose doesn't seem to mind.

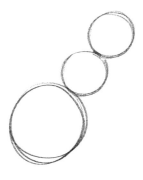

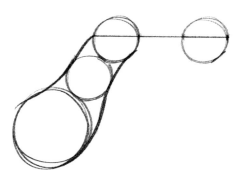

1 Draw a Series of Circles
Draw three circles stacked on top of one another at an angle with the bottom one being the largest.

2 Connect the Circles and Start the Nose
Add a circle for the nose and connect the original three circles with nice curved lines.

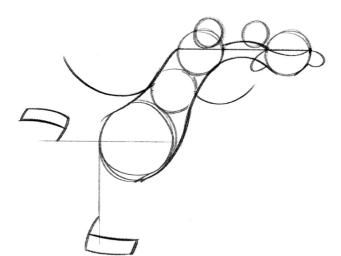

3 Continue the Nose and Start the Eyes, Wings and Legs
Following the curved line for the body, create the mouth shape. Add some circles on the top of the structure for eyes. Add some wing shapes and rough in the leg placement.

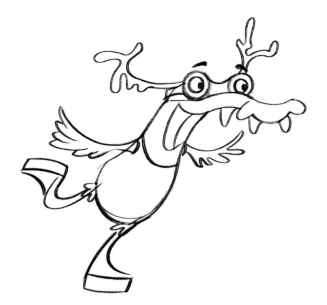

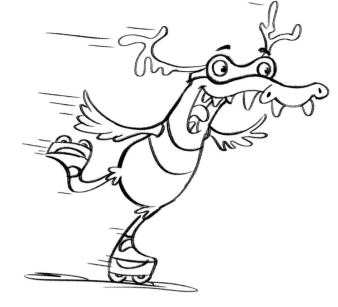

4 Add More Features
Add some crazy antlers, goggles around the eyes, large teeth, feathers for wings and nicely curved legs.

5 Add the Final Details
Add a tongue and nostrils. Finish the details on the body and the rollerblades. Add a scribble for the ground and some lines to the left of the monster to show how fast he's going.

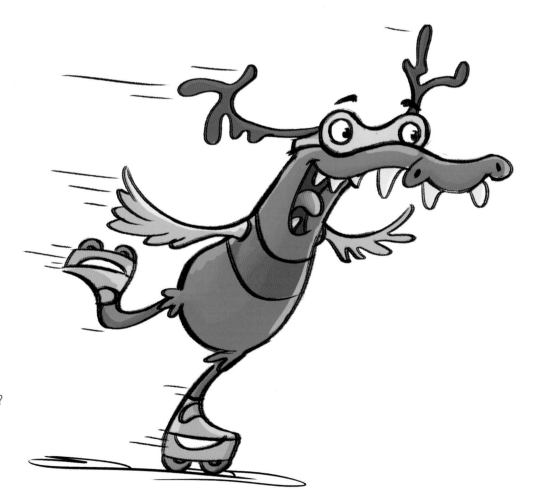

6 Add Color
Add color with your favorite art supplies. With his skates strapped on and rolling fast, Doogatormoose might think he's about to take flight. What do you think?

SaborGator

The SaborGator is a scary canine-wolf-zombie-gator-hound. He's adorable, but he's a ferocious little thing with a mean bite. Out of all my monsters, this character may be my favorite!

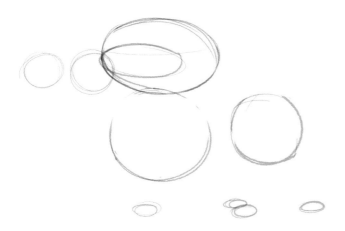

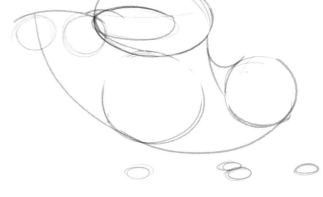

1 Start With a Series of Circles and Ovals
Start by drawing two large circles and a large head oval as shown above. Inside the head oval, draw a wide oval and two snout circles to the left. Draw four small feet ovals below all the other shapes.

2 Connect the Shapes to Form the Body
Draw a giant swooping line that goes from the center of the far left circle all the way to the far back end on the right. Draw a second swooping line from the back of the top oval, down to the far right circle. Draw two small arches to connect the snout circles and the smaller oval.

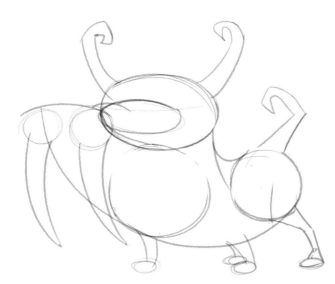

3 Add Horns, Tail, Legs and Fangs
Add some cool horns coming out the top of the head shape, then add a wicked-looking tail. Connect the feet ovals to the body and add some giant fangs coming out of the front of the two snout circles.

4 Add More Features and Shape the Feet
Add hair on his head, little spikes to the horns, and the nostrils, mouth and eyes. Rough in the claws.

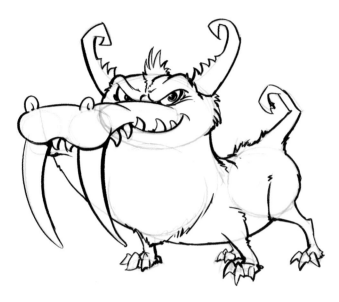

5 **Add the Final Details**
Add hair along the back and develop the eyes with pupils and eyebrows.

6 **Ink the Final Drawing**
Ink in all the details with a pen, and erase the light pencil lines.

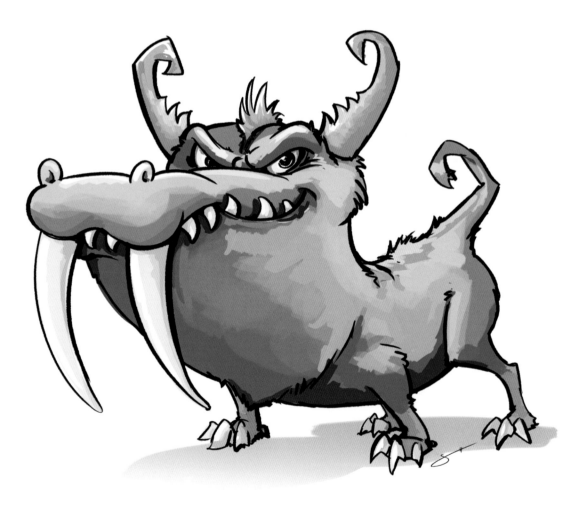

7 **Add Color**
Color and have fun! Unlike with Dewobble (in Chapter 3), I wouldn't let this guy lick anyone's face. It might scratch you!

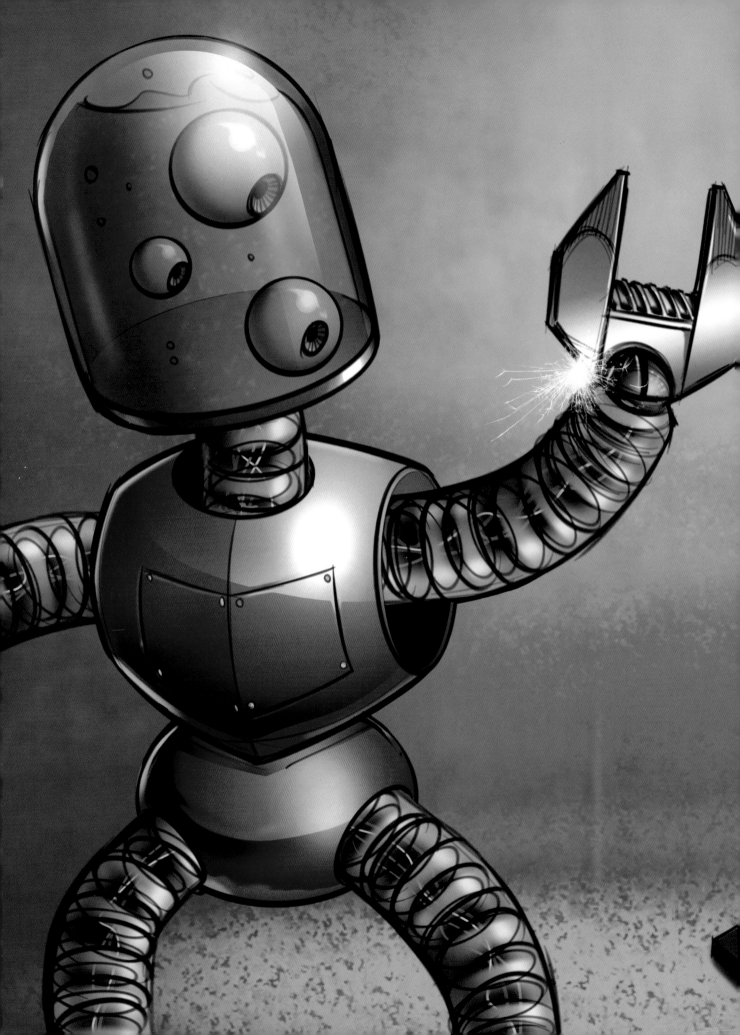

6 ROBOT MONSTERS

Dōmo arigatō, Mr. Roboto! That's Japanese for "Thank you very much, Mr. Robot" (and the lyrics to a famous song by the band Styx). Wheels, treads, telescoping limbs, rivets, straight lines and basic shapes are features of robot monsters. These characters are so fun, you may want to stop drawing to do the robot dance!

Tread

Tread is basically a can on treads that eats anything. I can already hear the whine of his little electric treads and the clanging of his glass and metal eyes bumping into each other as he races across rough terrain in his little robot world.

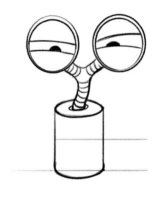

1 Start the Body and Eyes
Draw a rectangle, then lightly draw horizontal lines across the bottom and through the middle of the rectangle. Extend the middle line to the right. Draw a baseline below the rectangle at a distance that's equal to half the height of the rectangle. Draw two large circles for eyes hovering above the rectangle.

2 Develop the Eyes and Body Shapes
Draw two large circles inside the eyes. Draw ellipses for the top and the bottom of the body.

3 Add Eye Details and Connect the Eyes and Body
Add eyelids and pupils. Erase the straight lines of the top and bottom of Tread's body.
 Draw a hole at the top of the body and connect it to the eyes with a tube. Add bands to the tube.

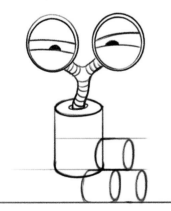

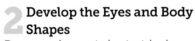

4 Draw the Right Wheels
Draw three vertical ovals using the guides to the right of the body. Lightly finish the wide wheels with curves on the left side of each wheel.

5 Add the Right Tread
Add the shape of the tread and erase the lines you don't need.

6 Add Wheel Details
Add curves to the inside of the wheels.

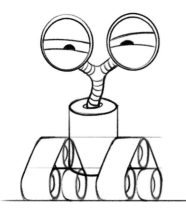 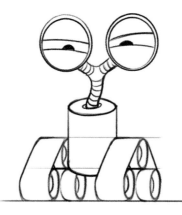 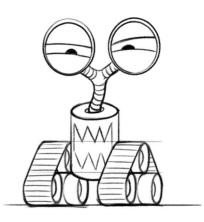

7 Draw the Left Wheels and Tread
Repeat Steps 4 through 6 on the left side.

8 Clean Up
Erase the tread and wheel lines that are behind the body.

9 Add Teeth and Tread Details
Add the teeth and the lines on the treads.

10 Add Color
Erase the guidelines and color your monster however you like. Tread is ready to eat whatever he sees with those great big headlight eyes. I wonder how he picks things up?

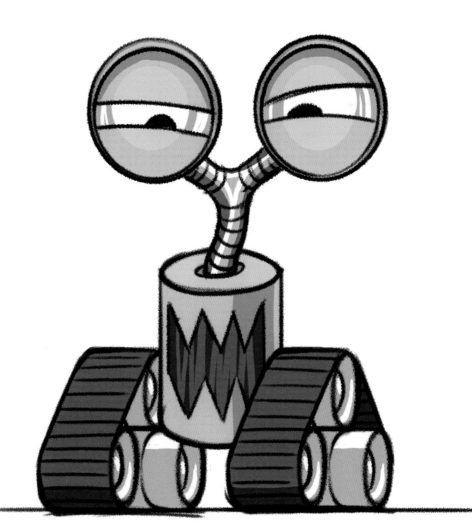

Eyebot

The primary objective of Eyebot is to take pictures and video of everything you do. Watch out, Eyebot has his eye on you!

1 Start the Body
Begin with a rectangle that is slightly tapered at the bottom.

2 Start the Eye
For the eye, add a circle that overlaps the top of the rectangle and is almost as wide. Then draw an inner circle for the eyeball.

3 Clean Up and Add Wheels
Erase the line behind the eye and draw two little wheels connected to the bottom.

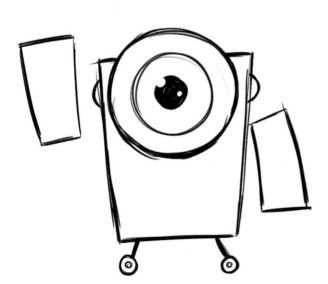

4 Draw the Shoulders and Forearms
Add half-circles for shoulders and two curved and tapered rectangles for forearms.

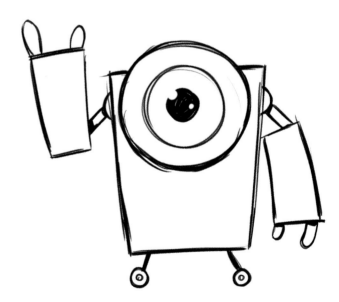

5 Draw the Upper Arms and Fingers
Connect the shoulders to the arms, and draw two sausage-shaped fingers on the end of each forearm.

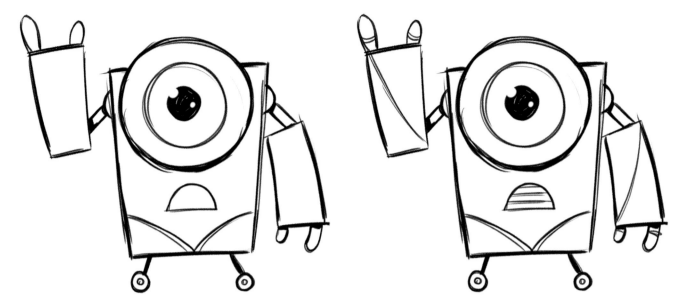

6 Add the Mouth and Body Details
Draw a half-circle below the eye for a mouth and a bending V-shape at the bottom.

7 Add the Final Details
Add the finger joints, grills for the mouth, and dividers on his forearms.

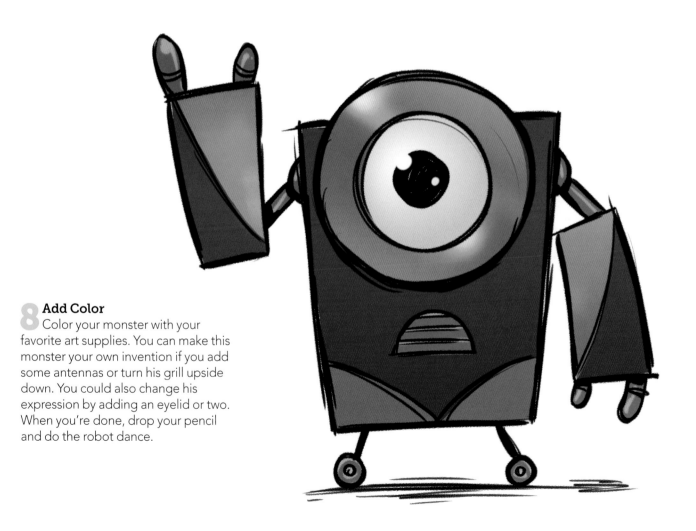

8 Add Color
Color your monster with your favorite art supplies. You can make this monster your own invention if you add some antennas or turn his grill upside down. You could also change his expression by adding an eyelid or two. When you're done, drop your pencil and do the robot dance.

Toaster

Toss two slices of bread in this Toaster robot and you may never see them again. It's kinda crazy how you can be inspired to make cool robot monsters just by making toast.

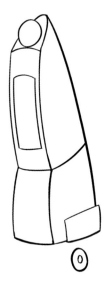

1 Start the Body
Draw a circle on top of a slightly curved rectangle shape. The rectangle shape is about four and a half circles tall. (You don't have to include the red circles and lines, or you can draw them lightly as guidelines.)

2 Start the Legs and the Back
Add some leg shapes to the bottom of the rectangle. The legs are about two and a half circles tall. Add a curved line to the right of the rectangle, stretching from the circle to about halfway down the legs.

3 Connect the Parts and Add a Wheel
Connect the legs with a curved line around the bottom. Draw a tall rectangle with a curved top inside the first rectangle. Now add a little box shape on the bottom right corner. Draw a wheel beneath it. Connect the top of the back to the rectangle with a U-shape behind the circle.

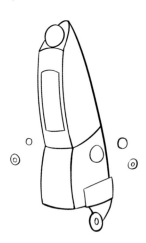

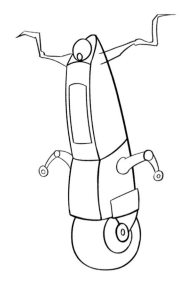

4 Start the Arms and Connect the Wheel
Add five circles as shown. These represent the arm joints. Connect the wheel to the bottom box with two curved lines.

5 Add the Horns, Arms, Eye and Big Wheel
Add some really cool horn shapes to his head. Then add an eyeball and a giant wheel underneath the body. Add curved lines to connect the arm joints, forming the arms.

6 Add the Final Details

Draw details on the joints of the horns. Add teeth to the mouth rectangle. Draw finger claws on the arms. Then add two rectangles (toaster slots) on the front of the body and an ear shape on the side.

7 Darken and Add Texture

Darken and thicken the outside lines. Add a button over his ear shape, and add some texture lines on his wheel.

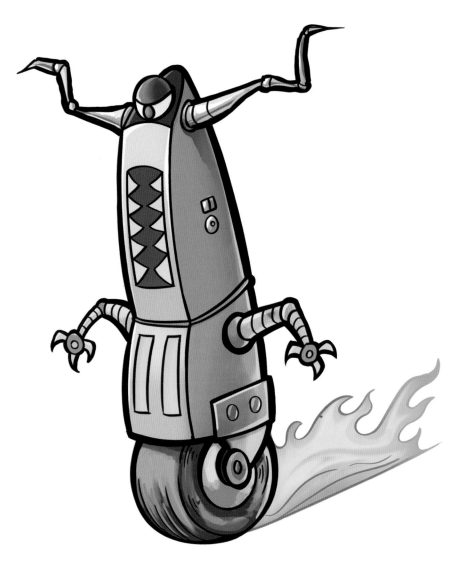

8 Add Color

Now have fun with some color. I added a giant flame, because he can move super fast with that rocking wheel!

Cydorg

Cydorg is half alien-dog, half robot, and a lot of tough. Don't mess with the Cydorg.

1 Draw Three Circles
Draw three circles, one floating above the other two (think snowman with a floating head).

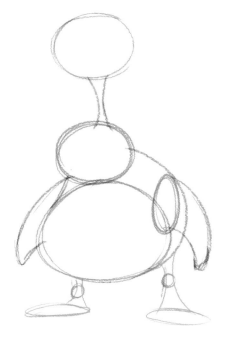

2 Draw the Neck, Arms, Legs and Feet
Connect the top two circles. Add an oval on the right side of the body (this is the base of the arm). Add the arms and connect the top part of the right arm to the center of the middle circle. Draw two little circles for knees and two long ovals for the feet. Connect those shapes to the body.

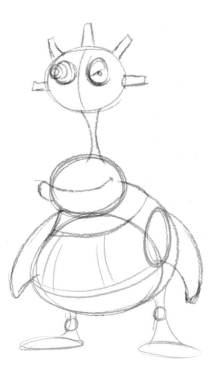

3 Add the Eyes and Mouth and Start the Armor
Add some cool eyes and spikes coming out of the head. Add a shape on the middle circle for the lower lip and mouth. Add some shapes to the body (this will become armor).

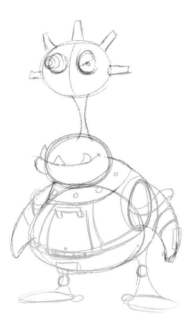

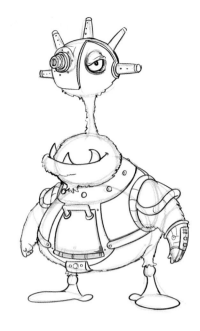

4 **Add the Final Details**
Draw the teeth. Add shapes to the body to develop the armor, including an armor pad.

5 **Ink the Drawing**
Ink over the pencil lines of your monster, and clean him up, adding detail to the wrist cuff and his spiky head gear.

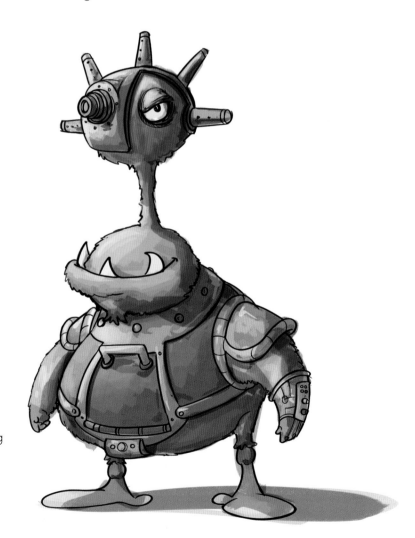

6 **Add Color**
Use any materials you like to color your monster. Cydorg is ready for battle and looking for his spaceship. Can you draw one for him?

Gorillabot

Not all robots are powered by artificial intelligence. This one definitely doesn't have a mind of its own. It's being controlled by a crazy little alien!

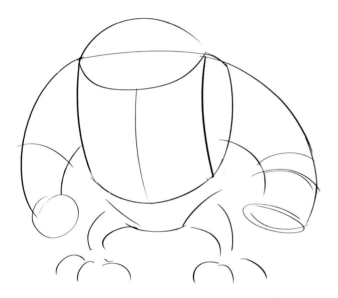

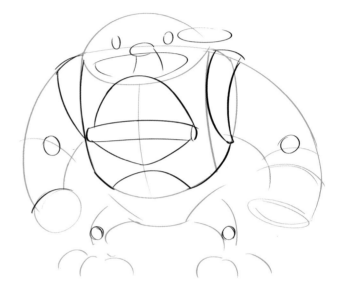

1 Draw a Rough Sketch
Start with a rough sketch to lightly draw the overall pose, using curved lines to sketch the body, arms, legs and helmet.

2 Add the Little Monster, Joint Circles and Mouth
Rough in the little monster who is driving this crazy bot. Draw light circles to indicate where the joints of the bot will be. Add the Gorillabot mouth.

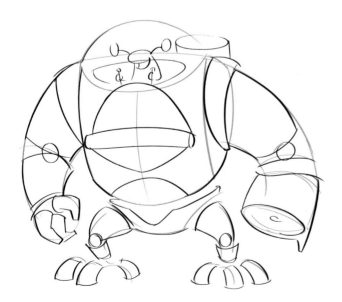

3 Develop the Basic Shapes
Firm up some of the basic shapes of this character and rough in the upper and lower arms, legs, toes and all other shapes.

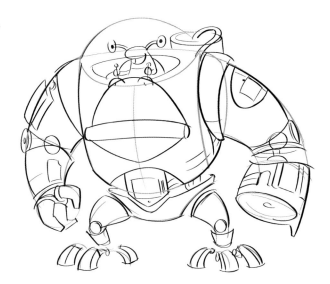

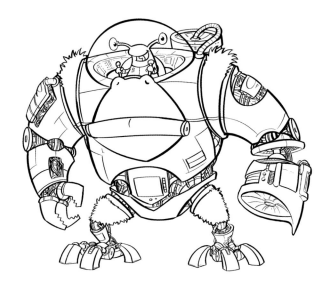

4 **Add More Details and Structure**
Start adding detail and structure to the entire monster robot.

5 **Add the Final Details**
This is the fun part: Go crazy and add small gears and wires and details like fur on the shoulders and legs. Robots look great with little details all over the entire structure.

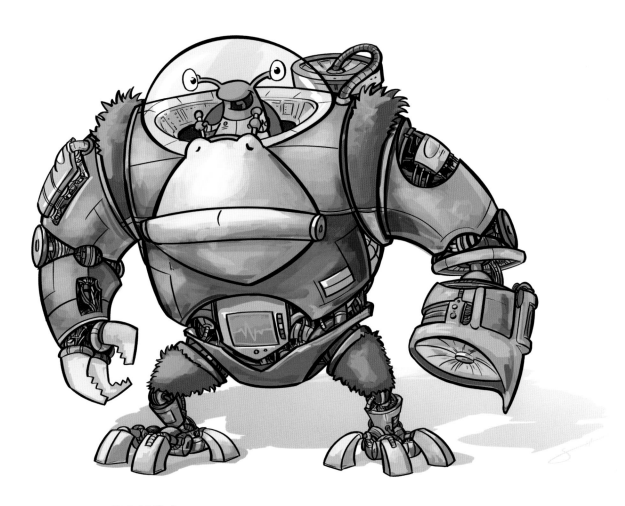

6 **Add Color**
Use your favorite art materials to color your creation. Gorillabot is built for battle. If you could build a robot and climb inside to drive it, what would your robot be built to do?

B.U.L.K.-790

Introducing the B.U.L.K.-790, a robot with anti-gravitational hovering power. What could such a strong robot do? I'll leave that up to you.

1 Start With the Shoulders
Draw a domed shape for B.U.L.K.'s shoulders. It's wide and has steep sides, with a slight peak near the middle. (Note: Draw this dome near the top of the page. His arms are long and hang down, so you'll need space for them on the lower part of your paper.)

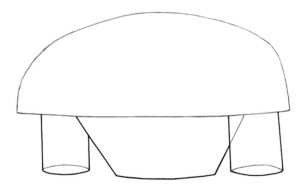

2 Add the Arms and Torso
Add two cylinders for arms, and an upside-down trapezoid (narrow end on the bottom) for the torso.

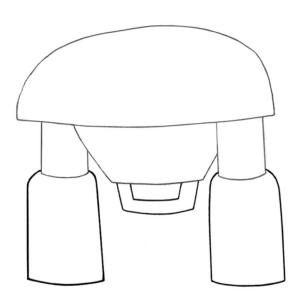

3 Add the Forearms and Stomach
Add wider cylinders for his forearms. The connection to the elbows is rounded, and the bottom of the cylinder is angled with a rounded bottom. Add two more trapezoids for the stomach area. These shapes are wider at the top, narrower underneath.

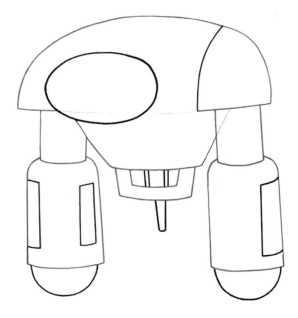

4 Draw the Head, Arm and Stomach Details and the Antigravity Rod
Draw a wide oval head sitting low on his shoulders, and overlapping his chest and the arm on the left.

Draw tall rectangles on the arms. Draw half-circles at the end of the arm shapes. Add a curved line to show where the right shoulder meets the arm.

Add a few vertical lines in the trapezoid stomach. Draw the beginning of an antigravity rod.

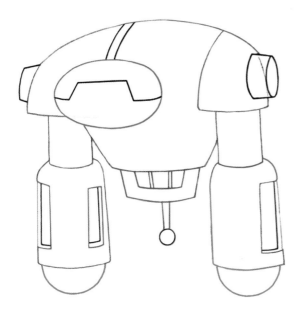
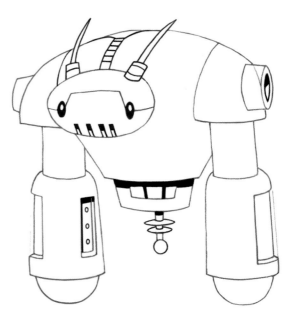

5 Add Head, Arm and Antigravity Rod Details

Draw a stripe from the top of the head then up the back. Draw a slightly angled line across the middle of his head from ear to ear.

Draw two short cylinders sticking out of the shoulders. Draw another tall rectangle inside each of the tall rectangles on the forearms.

Attach a circle to the bottom of the antigravity rod.

6 Add the Final Details

Draw two eyes and some little rectangle vents for the mouth. Just above his eyes, draw two short cylinders. Add curved lines and an antenna to the top of each.

Draw a valley where the stripe runs up the back, connecting the valley to the shoulders on either side. Add horizontal lines to that stripe. Draw the joint of the left shoulder as a short curved line next to the left antenna. On the panel on the left arm, draw three buttons.

On the antigravity rod, add a few oval-shaped focusing discs to direct the waves of antigravity. Add some shadows, and your robot is ready to rumble.

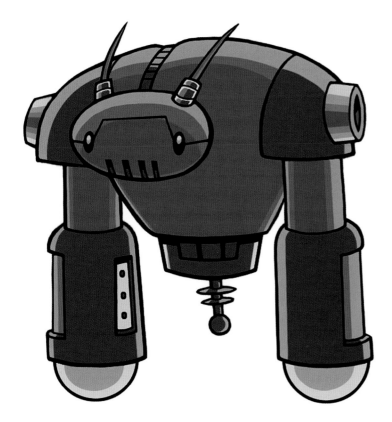

7 Add Color

Have fun coloring your monster. For your information, B.U.L.K. model 780 kept falling forward onto his heavy arms, which is why rollers were added on the arms for B.U.L.K.-790. I'd hate to be around when a B.U.L.K.-780 started falling down. Watch out!

Roller

The idea for Roller came from asking the question, "What if …" "What if there were a really fast two-legged robot on wheels? What would that look like?" Then I just started experimenting, and Roller was born.

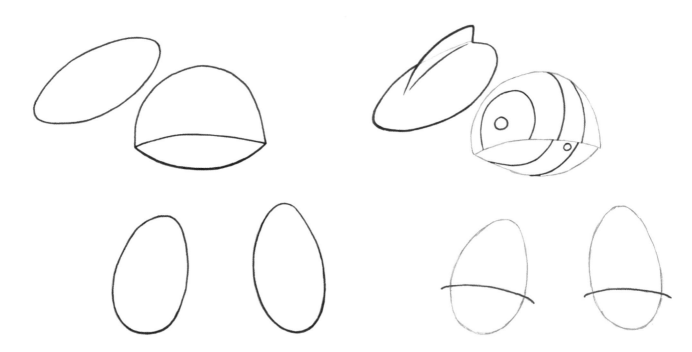

1 Start the Head, Body and Legs
Draw an ellipse (a stretched circle) for the head. The head tilts forward at an angle.

Draw two ovals for the leg wheels. The two shapes lean slightly toward each other.

For the body shell, draw a half-circle on top and a wide and narrow eye shape below.

2 Add Details to the Head, Body and Legs
On top of the head, add a fin to make him more aerodynamic. It runs about two-thirds of the way down the forehead.

Add stripes to the body shape. Draw a small circle on the left of the half-circle for the base of the neck. Add a small circle on the underside of the shell to connect the right leg joint.

Draw a curved line on each of the leg wheels to describe the casings that will cover the wheels.

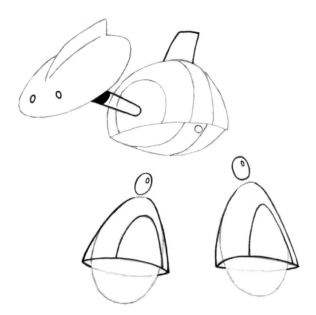

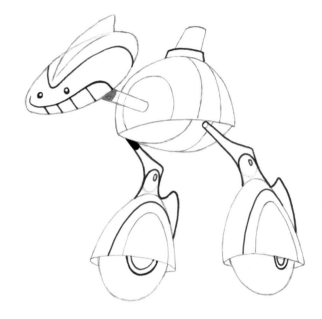

3 Draw the Eyes, Neck and Wheel Casings

Add Roller's eyes, which are just dots. Add a skinny neck by drawing parallel lines starting at the outer edge of the small circle to the head. Make a small shadow under the chin.

From each end of the wheel casing line, draw lines up at a slight angle to connect with the top of the oval. Make a half-ellipse shape inside the oval to create a cool pattern on the wheel casing. Two ovals above each of the wheel casings describe the leg joints. Draw a smaller oval inside the bigger one for the screws.

Draw a small rectangle on top of the shell (this will be a rotating light).

4 Add the Final Details

Connect the small circles under the shell to the legs with curvy lines.

Add a base to the rotating light on the back.

Draw fins on the backs of the legs. Add two half-circles on the wheels for hubcaps and two half-circles for the wheel casing pattern.

Draw a wide mouth with teeth exposed. (He really loves to race!)

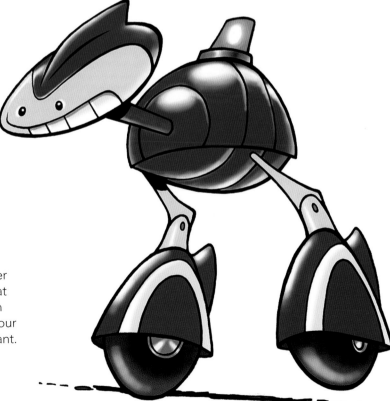

5 Add Color

Color your monster however you like. Roller just might be the fastest robot on wheels! What could you draw to make him faster? A rocket in the back? Perhaps rockets on his wheels? It's your monster robot, so you can do whatever you want.

CONCLUSION

Portrait of the Artist as a Young Man
Here I am in eighth grade and already an awesome artist!

When I was twelve years old, my mom carried out her threat to throw out our Atari and TV. We didn't have either for two years. (If you don't know what an Atari is, go ask your grandpa.) Instead of watching TV and playing video games, I focused on my sprouting interest and skills in drawing. I would make up my own superheroes, draw faces and cars from magazines, everything! When I was a student at Hawthorne Junior High School, I joined an after-school art program under the direction of an amazing art teacher named Bob Beason. Bob loved to draw comics, cool cars and fantastic creatures, and encouraged our creative spirit. He helped me believe that I was an awesome artist.

One of the most talented artists I ever met told me, "Drawing is like exercising. You have to work hard every day." This means that in order to get really good, to become a professional, you have to challenge yourself every day and practice until you get it right. Nothing valuable in this world comes without a price.

—Ernie

Early Drawings
I made these drawings in eighth grade, soon after I joined an after-school art program.

Get Free Stuff
Get an extra monster demo and learn how to draw more feet and tentacles at **impact-books.com/monster-factory.**

INDEX

ABOUT THE CONTRIBUTING ARTISTS

Let's meet the professionals behind some of the cute and cool cartoon monsters in this book!

Ken Chandler

When Ken was a kid, if he wasn't making friends with the monsters under his bed, he was drawing them. Dr. Seuss, Ed Emberley, Lee J. Ames, Bill Peet, among many others, fueled his imagination and inspired him to create more never-before-seen characters, monsters and critters.

In 2007, he graduated from the Illustration program at Brigham Young University, where he refined his monster-drawing skills.

When he's not conjuring up monsters, aliens or goofy-looking animals, he enjoys writing short stories. His latest and most ambitious project is an epic fantasy-adventure novel for kids.

Dedication: "I lovingly dedicate this book to my mom and dad. Thanks for believing in me … your little monster."

Scott Jarrard

Scott Jarrard grew up in the San Francisco Bay Area and later graduated from Brigham Young University with a Bachelor of Fine Arts in Illustration (1997). He began his professional career in 1995, when he was hired at Saffire, a video game developer. While there, he created in-game artwork for Nintendo and PC video games. Upon graduating, Scott joined Axiom Design in Salt Lake City, where he specialized in designing, creating and painting characters for Sony PlayStation games. In 2004, Scott set out on his own and has worked for himself ever since. After helping send the kids off to school every day, he makes the long commute to his studio (a.k.a. basement). Scott loves creating characters and illustrations for his advertising and entertainment clients, which have included Verizon, Microsoft, Mobil, Novell and NASCAR.

Scott lives in Salt Lake City, Utah, with his wife, their three children, a pet fish, a dog, a hamster and four chickens.

Dedication: "This book is dedicated to Amanda, for being my best friend, sweetheart and wife, and for all the fun and laughs along the way! You are my Sriracha!"

Share Your Monsters!
Don't forget to post your monsters on the *Monster Factory* Facebook page: facebook.com/MonsterFactoryBook. You'll also find free tutorials, contests and more!

ABOUT THE AUTHOR

Ernie Harker studied illustration at the University of Utah and Utah State University and began his professional career in 1993 as an illustrator for the Salt Lake City-based ad agency Dahlin Smith White. He founded a creative production studio called 8fish, Inc. in 1995, where he and his team of gifted artists and designers produced illustrations and animated projects for a variety of clients. In 2010, he decided to roll up his small business and take a full-time gig as the executive director of the CREATE department for one of his favorite clients, Maverik, Inc., where he leads a team of super-talented creative people.

He loves triathlons, outdoor adventures, cooking, drawing and hanging out with his eight brothers. Ernie lives in Draper, Utah, with his wife, Wendy, and four amazing children, Kiara, Mia, Bella and Max … and Twinkle the cat.

8fish artists produced *Making Faces: Drawing Expressions for Comics and Cartoons*. Ernie is also the author and illustrator of *They're Waiting for Me*, a children's picture book about the lengths a little girl goes to to avoid doing her chores.

a content + ecommerce company

Other fine IMPACT Books are available from your favorite bookstore, art supply store or online supplier. Visit our website at fwcommunity.com.

19 18 17 16 15 5 4 3 2 1

DISTRIBUTED IN CANADA BY FRASER DIRECT
100 Armstrong Avenue
Georgetown, ON, Canada L7G 5S4
Tel: (905) 877-4411

DISTRIBUTED IN THE U.K. AND EUROPE
BY F&W MEDIA INTERNATIONAL LTD
Brunel House, Forde Close, Newton Abbot, TQ12 4PU, UK
Tel: (+44) 1626 323200, Fax: (+44) 1626 323319
Email: enquiries@fwcommunity.com

DISTRIBUTED IN AUSTRALIA BY CAPRICORN LINK
P.O. Box 704, S. Windsor NSW, 2756 Australia
Tel: (02) 4560-1600; Fax: (02) 4577 5288
Email: books@capricornlink.com.au

ISBN 13: 978-1-4403-3881-6

DEDICATION

I dedicate this book to the amazing people who worked for me at 8fish, and to Bob Beason, my junior-high art teacher. Thanks for fanning the creative flame in me. You helped me set a course for a fun and exciting career.

Metric Conversion Chart

To convert	to	multiply by
Inches	Centimeters	2.54
Centimeters	Inches	0.4
Feet	Centimeters	30.5
Centimeters	Feet	0.03
Yards	Meters	0.9
Meters	Yards	1.1

Edited by Mary Burzlaff Bostic
Designed by Alexis Brown
Production coordinated by Mark Griffin

IDEAS. INSTRUCTION. INSPIRATION.

Download a FREE bonus monster demo at impact-books.com/monster-factory.

Check out these IMPACT titles at impact-books.com!

These and other fine IMPACT products are available at your local art & craft retailer, bookstore or online supplier. Visit our website at impact-books.com.

Follow IMPACT for the latest news, free wallpapers, free demos and chances to win FREE BOOKS!

Follow us!

IMPACT-BOOKS.COM

- Connect with your favorite artists
- Get the latest in comic, fantasy and sci-fi art instruction, tips and techniques
- Be the first to get special deals on the products you need to improve your art